The Snow Show

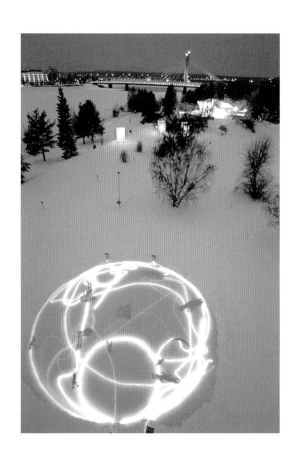

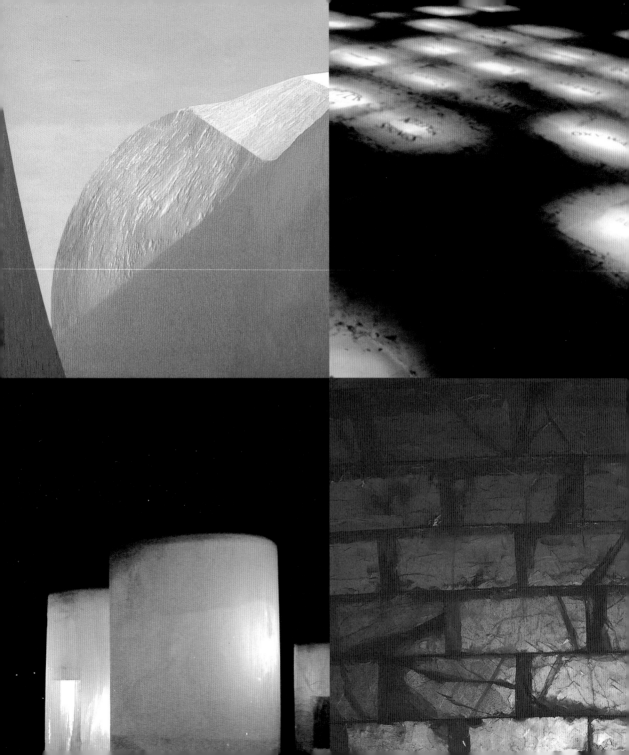

The Snow Show

Edited by Lance Fung

With 233 illustrations, 111 in color

Thames & Hudson

Foreword Musing on the Place in Art

Mary Jane Jacob, independent curator and professor,
The School of the Art Institute of Chicago

We go to locations far from home to have experiences because in our own time and place they are less exotic and we are less conscious of them. We seek out experiences as they make us feel alive and remove us from the compressed time and place of the everyday. In fact, it has become essential today to make time to reconnect, reground, recharge and then re-enter our world, and the experience of art is one of the ways to do this. We need to get away to have time to create, to write, to think, to see things (anew). By making art we offer ourselves and others a means of re-experiencing the world with a full sense of time. So, taking time by being in another place can provide an opening for creativity on the part of both maker and viewer.

Inspired by or contributing to a place's landscape and people, site-specific shows, or projects within international art biennials, have popped up around the world since the mid-1980s, so compelling is the realization that a place can be the basis for art. So meaningful, too, is the relevance of these works that emerge from an artistic practice that snakes its way through historical, contemporary and imagined places. For many of us, it is through books like this that we experience these places.

My first full-scale foray into site-specific exhibition-making was in 1991 in Charleston, South Carolina, where I curated the work of twenty-three artists for 'Places with a Past'. It is an experience that lives on with the residents of the region and in the work of some of the artists. My success as curator is always reaffirmed when, encountering someone I've not met before, they recount their experience of their favourite project and describe the installation in form and feeling with great detail. But, I also continue to be amazed by the vitality of similar experiences I hear about based on the publication alone. This is the achievement of *The Snow Show*, too: it is not only an exhibition catalogue but also an actual experience, proving that the artists' and architects' ideas have not completely evaporated.

One of the things that made 'The Snow Show' so unique as an artistic proposition was the challenge of place and media. Another uncommon characteristic was that artists and architects were asked to work together, to interact with a physical landscape, a cultural environment, materials and each other. The conditions presented new ways of working, offers of time to dream, to innovate and to create. Despite the hassle that getting out of the office, home, the everyday can be, and the hassle that airports have become, boarding a plane launches new possibilities as time and space open up. For the visitor to the show or for those native to the area, the work allowed them moments in which to pause and to take time to see in a new way.

Snow and ice as the materials of art and architecture are the outrageously exciting part. How to marshal these uncommon, unfamiliar and transitory elements? They are the quintessential media to command focused creativity. The project demanded and evoked a transformation of substance as well as place and the teams spoke of this over and over again, for example, Lawrence Weiner and Enrique Norten saw their project as 'a discontinuous composition with an open-ended result…to describe content and absence beyond time and space'. This extraordinary achievement was the exhibition's 'wow factor'. More than this, it was the nature of the material – open, fluid, always changing, possessing multiple states, malleable but never completely under control – that made the experience at once palpable and profound. It was the brilliance of the media that created, on one hand, a sense of being in the here and now and, on the other hand, an illusion or a dream. Transmutability, ambiguity and associative meanings were rich, and this book offers new layers of experience.

Just as the characteristics of site, collaboration and media add value to the projects, resulting in a greater vitality of engagement in the making and heightened experience in the finished viewing, so they magnify the complexity of the task. Hence, greater perseverance, trust and belief were required on the part of the organizers, in particular curator Lance Fung, who conceived and sustained his vision through the travails of the show's realization.

Contents

Introduction

Lance Fung, Curator

First conceived as an art exhibition, 'The Snow Show' quickly evolved into an unconventional experiment because of the unique and extreme nature of the factors involved. The idea of pairing artists and architects allowed in-depth insight into a rarely occurring, collaborative dialogue. The unusual and ephemeral materials of snow and ice provided a neutral playing field, because neither team member had worked with the requisite building techniques before. In flat, snowbound Lapland the seventeen partnerships produced projects that ranged from exercises in formal experimentation to highly conceptual artistic statements. Ultimately, the projects represented a process of exploration and flowed from an imaginative collaboration, not only between the artist's creative and the architect's more pragmatic vision, but also between the form of the building's design and the inevitable decay that was imposed on it by the materials involved in its construction, which were, by their very nature, perpetually changing. The visceral impact of the -45°C site was a fundamental ingredient in each work, and the experience of that environment was essential to an appreciation of the collaborative teams' efforts; fortunately, the photographs and the participant statements capture the grandeur of this experience.

Two simultaneous events inspired the exhibition. The first emerged from working with Robert Barry – one of the founders, along with Lawrence Weiner, Douglas Huebler and Joseph Kosuth, of the conceptual art movement – on a public art commission situated in a university building. Barry initially conceived a text-based work to be etched onto the glass windows of a high-ceilinged, circular lobby so that the play of natural and artificial light affected how the words were visually and conceptually perceived. Once the chief architect entered the equation, communication about the artwork's integration in the university building became very one-sided, and the schism between artist and architect appeared. The process provided an intriguing glimpse into

artist-architect relationships, but 9/11 prevented the project from being realized.

The second event was my preparation for an exploratory trip to Scandinavia. I decided to visit established cultural institutions (museums, theatres and architectural masterpieces), but also to seek out some of the more kitsch undertakings. I found the Nordic love of their winter climate interesting: they make snow castles, harvested-ice hotels and an array of representational objects from both. In my home town of New York City, we learn to deal with snow as merely an obstacle; in Scandinavia, it is used for play, profit and tourist attractions. For me, however, temporary winter structures offered exciting possibilities for young artists. After discussing the idea of inviting an architect to design a snow museum to house ephemeral art installations with friend and Stedelijk Museum curator Marja Bloem, she suggested that I research the relationship between master architects and installation artists. The notion of creating collaborative artist-architect teams began to solidify as the core curatorial premise and gave birth to 'The Snow Show'.

Although many established snow- and ice-related events exist, such as the Sapporo Festival in Japan and the Harbin Festival in China, 'The Snow Show' differs from these as an art exhibition. At Sapporo, massive amounts of snow are packed and then carved into well-known historical buildings or structures, such as the Egyptian pyramids and Big Ben. At the Harbin Festival, only harvested ice blocks create large forms carved into elaborate dragons and pagodas. 'The Snow Show' used the same materials but focused on contemporary art and architecture to interpret the use of the materials in a more rigorous manner.

I began to research contemporary architecture to select the architects who would be invited to participate; this research inspired me. Without bias, I culled through everything pertaining to architecture and its creators. Conceptual and sculptural architecture and theory captured my imagination as it intersected with the interests I have within fine art. While investigating artist-architect relationships more closely, I discovered that little creative interaction between the two worlds existed apart from the

odd globally recognized museum-building projects intended to add a 'brand identity' to a city. Museum design seemed to fall into two very distinct categories: either great white boxes offering unadulterated exhibition spaces, or museums that were themselves conceived as artworks – Daniel Libeskind's Jewish Museum in Berlin or Frank Gehry's Guggenheim in Bilbao, to cite two obvious examples. Historically, there has existed a division between the practices of art and architecture, but a great shift is currently taking place, particularly in the latter profession. Architects today are just as likely to be influenced by Richard Serra or James Turrell as by Mies van der Rohe, and artists, who rarely address themselves to experimental architecture, are increasingly being exposed to experimentally architected work. It is this very overlap of practices that forms the heart of 'The Snow Show'.

The curatorial process of partnering artist and architect was extremely difficult. Even though the process terrified me, it constituted the basis of the show as I recognized that successful teams would guarantee the best results. Despite the fact that the individual participants were equal in talent and had the capability to develop works on their own, an interdisciplinary discourse had to occur. I received varying advice on how to shape the seventeen teams, but I followed my instincts and intuition. After meeting with all the participants, I searched for similarities in purpose, aesthetic and philosophy, which would allow for additional surprises and links within the partnerships.

I hoped to show the full range of current theoretical thought in the fields of both contemporary art and architecture through the selection of the different participants. Once partnered, each team developed a project with the following parameters: a maximum footprint of 1,000 square feet (100 square metres), though a few projects exceeded this area; a ceiling height of no more than 30 feet (9 metres); and a material composition of at least 80 per cent snow and/or ice, and 20 per cent other materials for either aesthetic or structural reasons. Most teams decided to use purely snow and/or ice; those that used other materials generally did so for artistic purposes.

Most artists found it amusing or intriguing that their architect-partners, whose professions are based on building permanent edifices, were creating works that they knew would disappear in six weeks. Actually, few of the architects embraced the idea of impermanence, but they definitely embraced the materials. The artists were equally inspired by the materials, which were for many of them a pivotal factor in their participation. From my perspective, the idea of using an unfamiliar material equalled the collaborative process. I was astonished when confronted by the innate beauty of the material and the intense visual experience that the teams were able to achieve through its use.

My idea of collaboration also shifted over time, allowing for a range of approaches. Initially, I aimed for a 'utopian collaboration', in which each participant would have equal influence and the finished work would be a complete fusion of styles. In some cases, this process occurred and one saw glimpses of both styles in a project. In other instances (which I fought from the start, but quickly realized were part of the process of collaboration), some teams engaged in a 'traditional collaboration', in which one partner took the lead and a division of responsibilities between artist and architect facilitated a smooth collaboration. At the conclusion of this complicated experiment, each team had found their own course of methodology, mainly somewhere between the two extremes of utopian and traditional collaboration.

In the end, 'The Snow Show' offered an insight into the differences and similarities between artists and architects. Due to the rigor of the discourses, the designs and their execution, the technical capacity for building with snow and ice was advanced far into the future. As the character of the materials was far less important to me than the issue of collaboration, I feel we are only at the beginning of a process of creative and cultural collaboration that can take any number of forms. I look forward to watching and assisting in the further investigation by co-creators working towards intellectual and material advancements.

Artist Carsten Höller and architects Williams & Tsien were teamed together for a number of reasons. I wanted the exhibition to reach out beyond the small circles that constitute the worlds of art and architecture and to leave a lasting educational mark. High culture is often seen as exclusive and inaccessible. However, considering the location and the materials involved, accessibility to and interaction with the public was an indispensable element of 'The Snow Show', and this team showed a keen awareness of the social and cultural aspects of the project. Höller often works with the slide as a visual metaphor and Williams & Tsien delve into the same formal concerns that traditionally preoccupy visual artists: colour, surface quality and materiality. The collaboration yielded a simple plinth of snow with a submerged central courtyard into which a series of slides descended. The formal beauty of the piece appeared when it was put to practical use by the children and adults by either shooting down its slides or, for the less daring, by walking through it at a leisurely pace.

It was clear from the beginning that Asymptote's founders, Hani Rashid and Lise Anne Couture, wanted to concentrate on the architectural form of the project, while artist Osmo Rauhala wished to focus on the interior video projection. Each partner seemed to gravitate to what interested them most. In spite of Asymptote having more exposure in international art exhibitions than their artist partner, the artist was given complete freedom with the video projection. The idea of building a large organic form located parallel to the sea was poetic, as was the hope that at a distance the double-sided building would almost disappear into the horizon. To build such a provocative structure proved a struggle and weather conditions tested the flexibility and patience of everyone involved. For weeks the temperature was - 55°C, making it impossible for the equipment and the workers to function. Asymptote carefully designed the elegant and clean rotating oval panes of glass through which the video projection passed to reach the curved walls with a natural, almost Buddhist, movement. Poeticism seemed to permeate the project, radiating from within through to the outside.

Emerging Irish installation artist, Eva Rothschild creates mythical, spiritual objects that often include crystals or mirrors and uses black magic as inspiration, while Greek architectural firm Anamorphosis concentrates on the psychology of architecture, of space and of materials. Rothschild's sculptural work tends towards installation-oriented projects, which forced her to wonder how her inspirations would be incorporated into an architectural context. Anamorphosis carefully listened to her concerns, and her desires figured in the final design. The idea to build a monumental amphitheatre excited me because it meant that the architects were using a form from their national heritage. Classical Greek architecture was designed for permanence but, in contrast, Anamorphosis built an iconic form that welcomed its accelerated reduction to an archaeological ruin in only six weeks. Rothschild gathered the remains of the other ice constructions and used them to pour, à la Smithson, a disruptive and prophetic line of rubble composed of ice crystals. The contrast between this line of rubble and the purity of the architectural form gave the work an immediate contemporary resonance.

The work developed by artist Rachel Whiteread and Juhani Pallasmaa was the smallest in the exhibition. The purity, simplicity and quietude of their work ensured that their collaborative effort would be the precious jewel of the show. Unlike so many of the participants, Whiteread appeared more interested in the opportunity to experiment with form than with the novel material of snow. Having created a number of pieces based around the idea of casting a void space, here she cast a positive space and transformed it into the void. Responding to this inverted approach, Pallasmaa observed that 'architects who make art make decoration in the end; artists who make architecture make spaces that don't function well'. The form of the staircase occupies a special place of interest for Whiteread and Pallasmaa: their common fascination with staircases allowed them to immediately find a meeting place for the interior form and Pallasmaa's beautiful exterior, designed with an elemental and minimal aesthetic, which seemed to move along with the visitors as they walked to

either entrance. This physical illusion was mimicked inside; visitors had to duck under a low spot to cross to the other end of the twisted interior.

Five cylindrical forms cast in ice created small intimate environs for conceptual artist Robert Barry and the architectural team of Saija Hollmén, Jenni Reuter and Helena Sandman. Barry selected a word to be carved into each structure and focused on the precise placement of each word to ensure that the words themselves would be ambiguous and magical. Hollmén, Reuter and Sandman concentrated on the overall site, aligning the objects with the constellation of Ursa Minor. Yet, up close, we could see our own breath freezing onto the surface of the ice and the confined interior space made us feel at one with the ice in a very meditative space. This appropriate use of process did not require an actual fabrication from ice blocks, but allowed Mother Nature to do much of the heavy lifting.

Thai artist Top Changtrakul and Giuseppe Lignano and Ada Tolla from LOT-EK produced a bold and direct statement, like a powerful cut into the canvas by Lucio Fontana. Using concrete moulds to cast coloured walls resulted in parallel, striated red walls that directed the viewer's path on their entrance to the exhibition and sliced the site in two. The participants constantly pushed and pulled until, as in any relationship, a mutual respect emerged. The veils of gentility disappeared when the three members of the team spoke directly to one another and a utopian collaboration took hold. As direct as the three strong yet flexible personalities that created it, the form incorporated 162 fluorescent lights and possessed a beautiful rawness. The team emphasized the casting process by incorporating the wall moulds into the finished interior and exterior form. Thankfully, the confidence and brilliance of this team produced a project that did not simply rely on the intrinsic beauty of ice; the piece's harshness gave it strength and unapologetic power.

Ernesto Neto and Kivi and Tuuli Sotamaa from Ocean North concentrated on the simple process of ice freezing. In installations that often incorporate unexpected materials, Neto creates funky, unconventional, large-scale organic environments. The collaboration produced a unique result that acknowledged the local culture. Scandinavians often place a bucket of water outside overnight so that it freezes, then poke a hole in the centre at the top and throw away the superfluous water to create an ice lantern. The appeal of this technique lies in its simplicity and in its reliance on a natural process to achieve a useful end; this team used the same technique on a much larger scale. Their resulting giant space was marked by a shifting pattern that was a cause of the freezing process and illustrated the changes therein. The interior void felt womb-like, whether glistening in the sunlight or beckoning in the deep darkness of the Lapland night.

Meetings between Lawrence Weiner and Enrique Norten produced a powerful discourse and a wonderful collaborative drawing in which Weiner first created a sketch upon which Norten overlaid his thoughts and which they subsequently used to concretize their plan. The face-to-face working sessions created a series of large slabs of cast, coloured ice – blue, green and clear – arranged in what Weiner described as a kind of 'anti-building'. Like the foundations of a building, the piece was ghostly, merely the basis on which an architect might embellish a structure. Weiner then focused his mind on the site and the quality of the northern light to create the text, consisting of two words, 'obscured horizons', encased in a linear box and carved into the walls of ice in three languages: English, Spanish and Finnish. It was gratifying to witness this simple, fluid and quick development of a commanding work of art and the lasting friendship between the two creative forces.

Certainly, Zaha Hadid conceived the most ambitious and challenging project, designing twin monuments of snow and ice. The warmth with which she welcomed me into her studio and her rigour in design matched her commitment to the 'The Snow Show'. The builders worked to a tight timeframe and had to develop new surfacing tools in the final days before the show to perfect the two huge forms. The creation of *Caressing Zaha with Vodka* by Cai Guo-Qiang was equally dangerous. His challenge was how to plumb the vodka, which would be burned, and to ensure

that it would relate to and interact with the Hadid designs to do justice to her many weeks of labour. A moment of exhilaration hit me when witnessing the vodka on fire in an orange blaze that shifted in colour to Cai's deep and desired cobalt. The previous three years of devotion to the show were validated for me when I experienced all seventeen works by day, but, surprisingly, the show truly came alive under the magnificent northern lights. Complete peace and pride struck us – myself and so many selfless and helpful volunteers – when Cai's first match ignited the vodka.

Jene Highstein's skilled hand as sculptor complemented Steven Holl's formal architectural master-pieces. Their idea – to concentrate on basic forms such as the cube and sphere – optimized the beauty of the lake-harvested ice. The simple form transcended art and architecture, creating pure wonder. The most substantial benefit of happenstance was the curved interior wall that turned the simple form into a musical instrument. Although I had intended to include elements of sound in 'The Snow Show', no team elaborated on this idea; the Highstein and Holl work, however, incorporated sound in a primal sense. Like the slides of Höller and Williams & Tsien, this poetic form of perfect proportions became a catalyst for community interaction. Impromptu 'happenings' filled the void, as echoed sounds from far beyond the site – singers, musicians and children's laughter – could be heard throughout the day and night. The work achieved a true experiential transcendence.

Internationally renowned, Japanese architect Tadao Ando creates elegant buildings defined by the sublime use of natural light and elemental materials, often concrete, as the basis for construction. Tatsuo Miyajima is known for his exquisite minimal installations that, using LEDs, deal with the perception of time. Despite coming from the same area of Japan, the two had never worked together. Their piece was a seemingly never-ending parabolic tunnel, containing spiralling LED lights that formed permutating numeric characters. It raised issues of timelessness and spirituality and created a visceral experience when walking through it.

When speaking with Yoko Ono, one of the first artists invited to participate, she imagined a jail made from ice. Later, when partnered with friend Arata Isozaki, the jail became a penal colony. I thought the new direction was subtle until I walked through the maze-like interior. Isozaki's decision to have each viewer use individual cast ice votive candles as their light source related to Ono's previous candle and performance works. The massive amount of ice (over 800 huge blocks) had a heavenly quality. In the warmer moments, when temperatures climbed as high as -10°C, a translucency allowed the viewer to almost see through the three different layers of 1.5-metre-thick ice walls. When temperatures dropped, the ice surface frosted with a texture that called out to be touched. If lost in the middle of the maze, an upward glance at the blue sky or the northern lights freed one from the almost oppressive ice. The viewers' passage through the maze contained moments of claustrophobia but never of hopelessness or confinement; instead, the work gave one a feeling of hope and escape.

Master of materials and installation, Korean artist Do-Ho Suh designed a mathematical arrangement of fibre-optic lights, intended to be cast into an ice floor to create a striking optical illusion. Due to budgetary reasons, the floor was radically reduced to a single human-sized column of ice and light, which should have had an equally powerful result. However, Do-Ho Suh quickly recognized that the clarity of the fibre-optic lighting pattern and the overall form differed from his plan, so the object was removed. The experimental freezing of the red bubbles in the sea by Do-Ho Suh's architect partner Thom Mayne of Morphosis, on the other hand, succeeded in spite of many technical problems. The organic red pigment leaked into the sea, and discoloured halos appeared around the bubbles. After much effort, a powerful visual project stood in competition with the amphitheatre. In the end, Do-Ho Suh felt that his many discussions with Thom Mayne had influenced the form, the scale and the site of the project, allowing him to see his work in the erected walls even without the planned fibre-optic totem or floor.

The partnership between artist Lothar Hempel and Steve Christer and Margret Haroardottir of the architectural firm Studio Granda produced a somewhat more ethereal and contemplative scheme than the other teams. They rejected the idea of designing a traditional building and initially explored the idea of constructing a giant, fully functional stereo speaker made of snow. Eventually, they presented a traffic light with a bicycle chained to it that rose from a pool of bubbling and surging hot water. It was a magical vignette in the landscape, begging us to reconsider our preconceived definitions of architecture and urban space. The traffic light directed the viewer to nowhere, and the steam that rose from the pool froze onto the surrounding trees, creating a kind of sheltered enclave. An incredible snow structure grafted onto the trees, while a barrier of steam surrounded the pool's perimeter.

The ease with which Anish Kapoor makes sculptures on both a monumental and a human scale corresponded with the sense of proportion and materiality in the work of Amanda Levete and Jan Kaplicky of Future Systems. I anticipated a utopian collaboration as they had worked together in the past, but this was their first project to come to fruition. The partners immediately decided to use colour and an unprecedented spraying technique to carry out their project. Many layers of red-coloured water were sprayed on top of a wooden mould; the hope was to blot the landscape with a sculptural gesture, which would be seen from both sides of the river and would add diversity to the other rectilinear projects. Light emanated through circular holes and a hollow at the back end of the impenetrable structure. The work added a significant sense of whimsy to the exhibition.

The change from day to night affected the sociopolitical statement by environmental artist John Roloff and architectural gurus Elizabeth Diller and Ric Scofidio. A mesmerizing grid of eighty-one squares of ice, extracted from the surface of the frozen sea, were filled with eighty-one brands of bottled spring waters, from regions as distant as Afghanistan, Italy, North Korea and the United States. Raising subtle political questions, the team commented on the commercial exploitation of local waters for re-dissemination in a global marketplace. The dimly lit logos etched on the surface of the squares haunted the sea, while the fumes rising from the industrial plant in the distance illustrated the impact of industry and public consumption on the natural environment. As the climate changed, the blue sky cast shadows upon each logo, creating the impression of tombstones. The conceptual framework of the piece dictated that it would only be fully realized when its identity as a piece of architecture ceased – with the warmth of spring, the sea would slowly claim the work, the logos would fade and the international waters would mingle with and be absorbed into the sea.

If there is an exception to every rule, the project by Kiki Smith and Lebbeus Woods was certainly it for 'The Snow Show'. Responding immediately to each other's ideas, Woods and Smith created something totally different: an aging ice pool, an artwork that simultaneously managed to be a work of nature and a human-made architectural space. To make the piece, they excavated a large, shallow hole that measured 13.7 metres in diameter and filled it with water in five layers, allowing each layer to freeze separately. The figures that Smith had drawn and laser-cut out of stainless steel were frozen under the top layer. Side-emitting fibre optics were inserted in the ice to create a kind of painting with light and to bring the work to life. Daylight gave the piece a subtle appearance, and, when it snowed, it was completely obscured. Despite its slippery nature, the circular pool was an inviting surface. Looking down into the mysterious pool at night, one saw submerged figures against the reflections of the stars above.

After three years of challenges, a great deal has been achieved by 'The Snow Show': technical advances, an invigorated interest in interdisciplinary collaboration and many lasting relationships between all involved with the impassioned experiment. The projects, although now melted away, still remain firmly etched in the memories of the fortunate few who personally experienced the show; through this book we hope to bring the wonder and beauty of 'The Snow Show' to you all.

Carsten Höller
Williams & Tsien

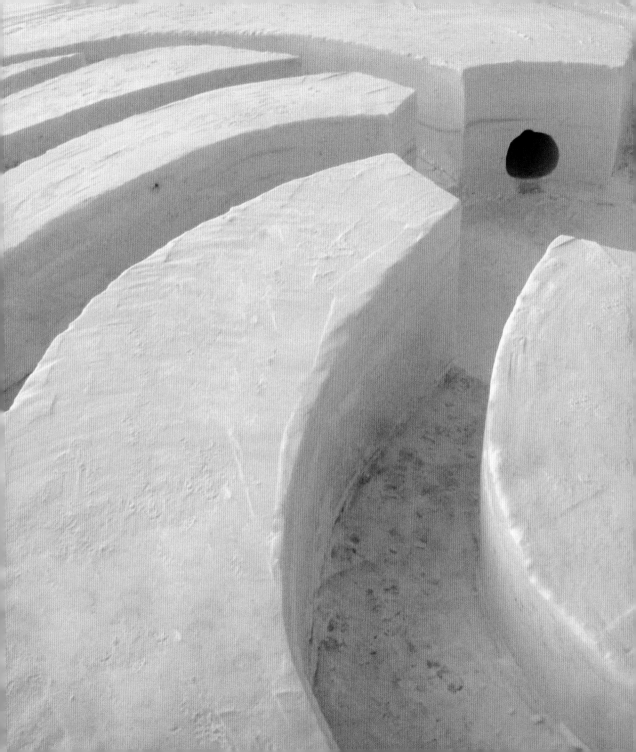

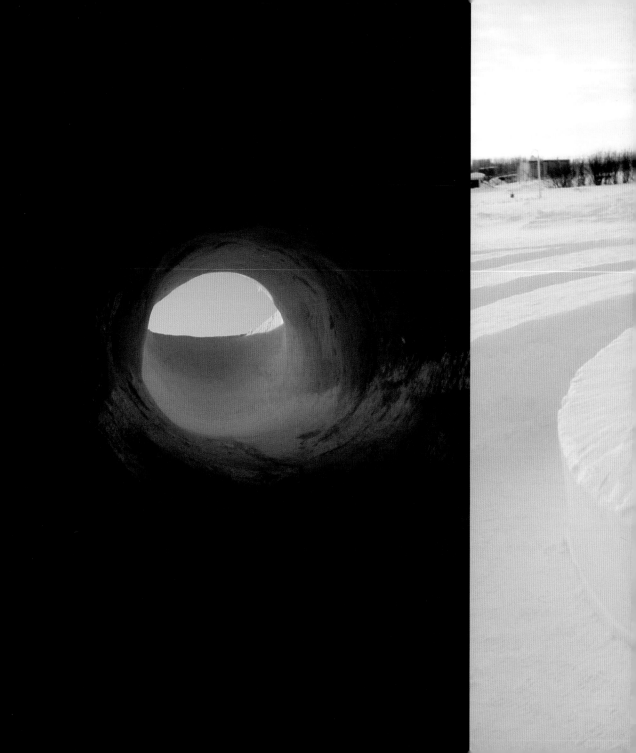

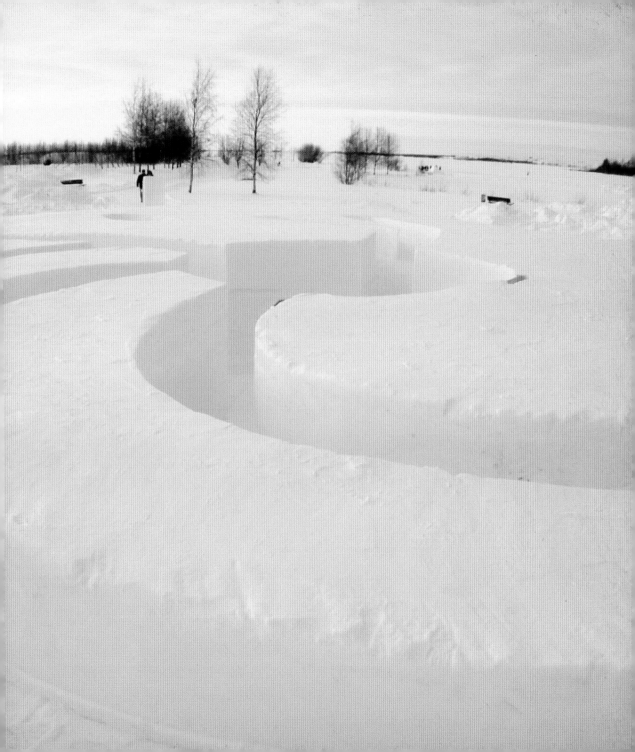

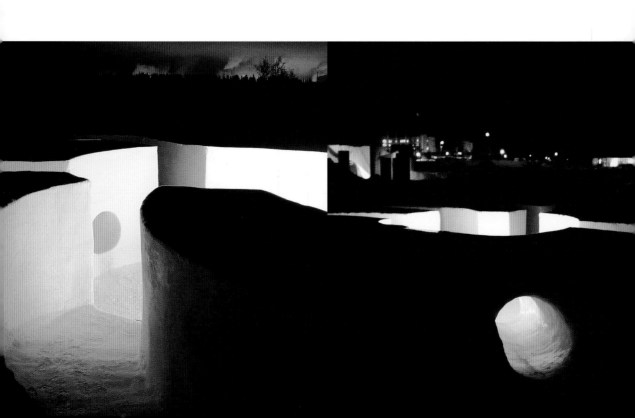

The inherent beauty of the plateau was fully appreciated when visitors used the work of art/architecture for its intended purpose: play.

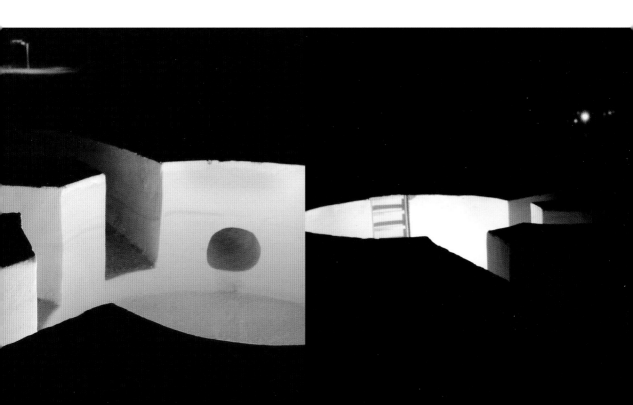

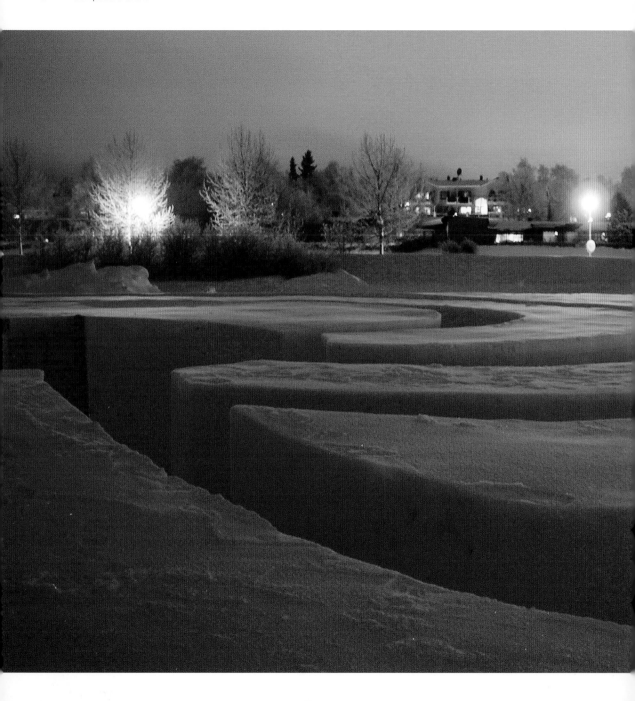

Osmo Rauhala
Asymptote

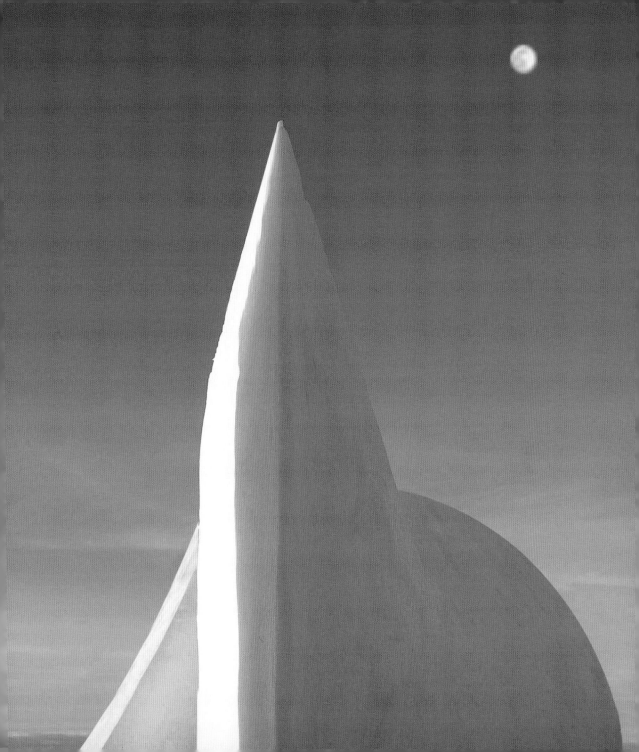

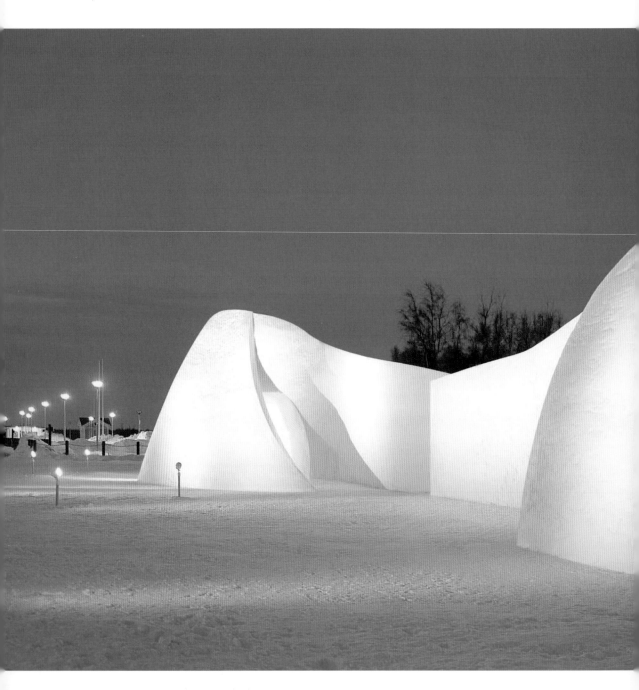

Absolute Zero: A Light House of Temporality

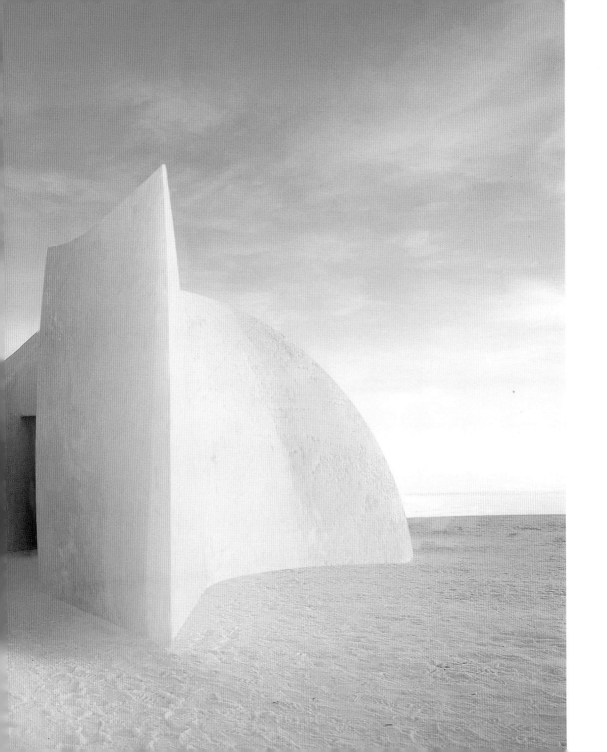

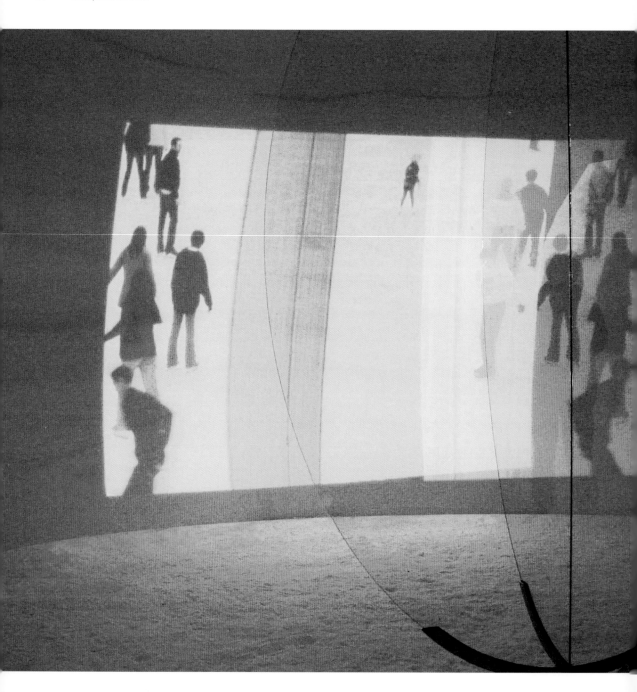

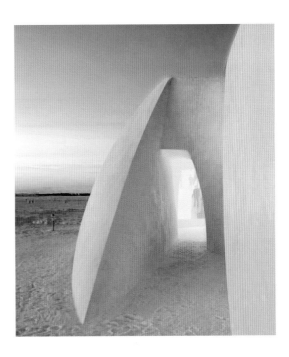

Absolute Zero: A Light House of Temporality

Eva Rothschild
Anamorphosis

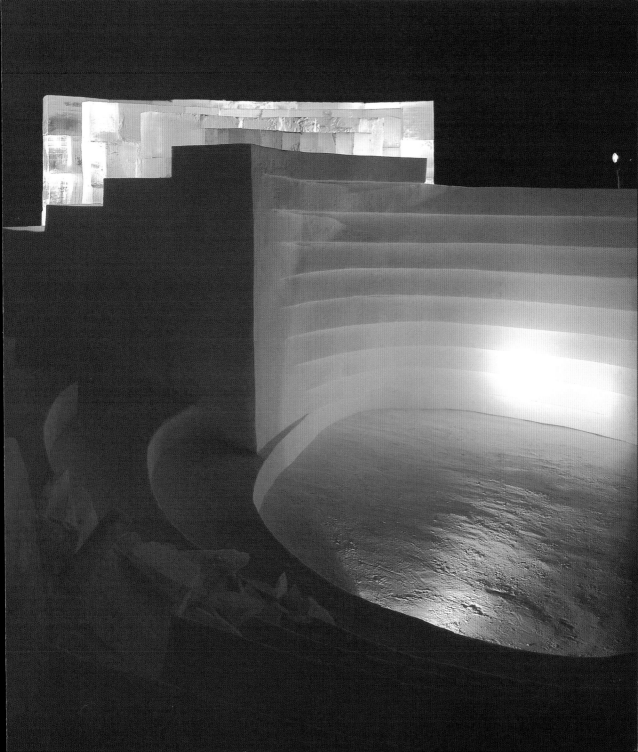

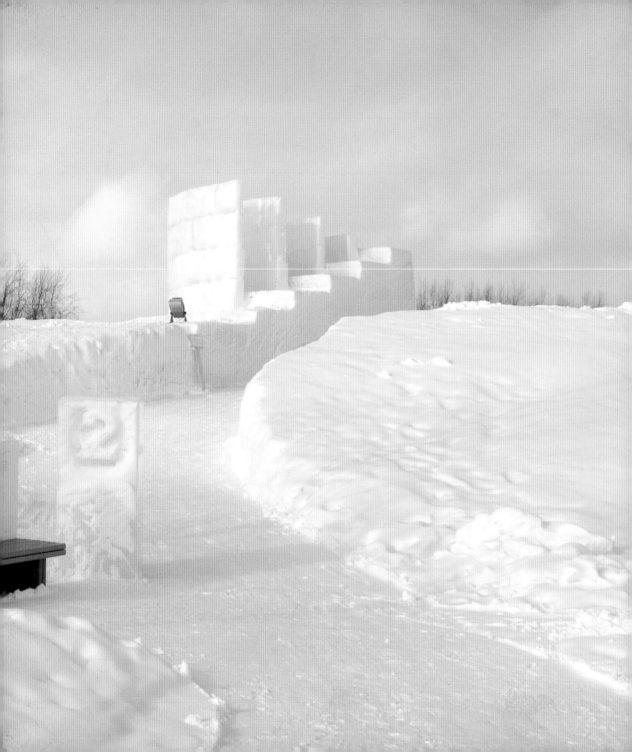

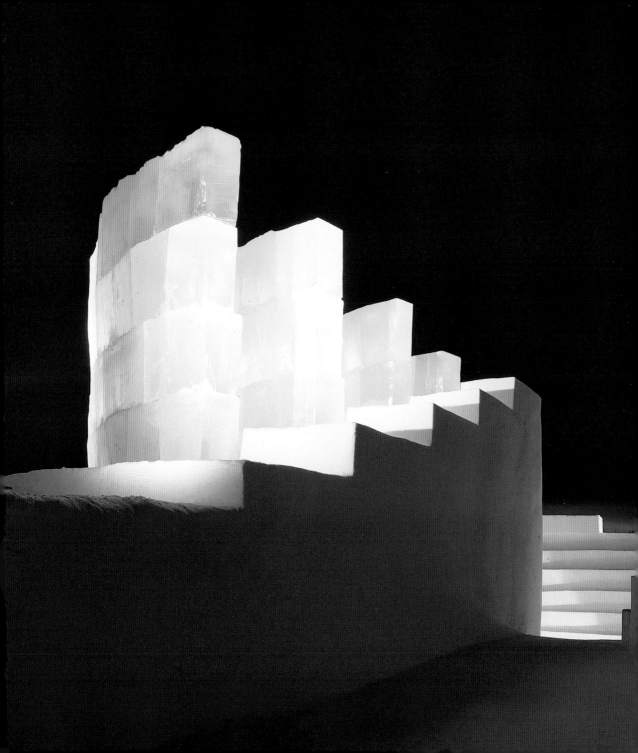

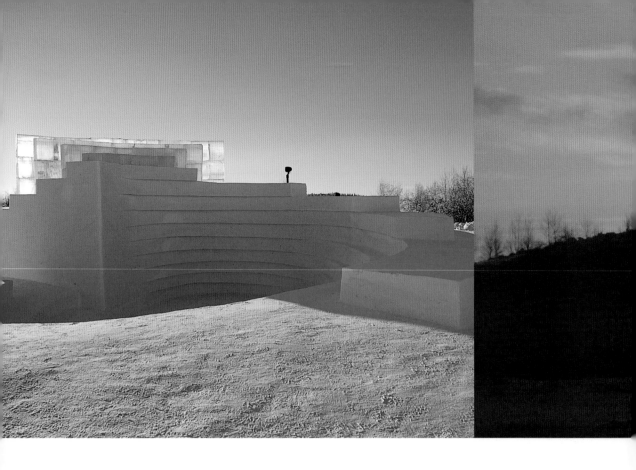

The project had a sense of archaic structure,
of first forms, rooted in basic shapes.

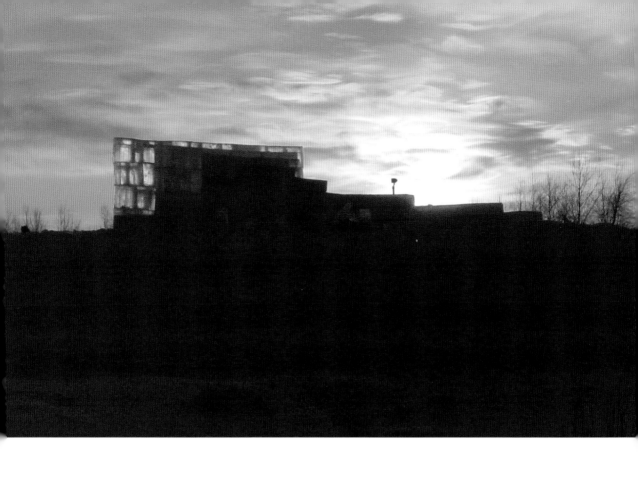

The Morphic Excess of the Natural/Landscape in Excess

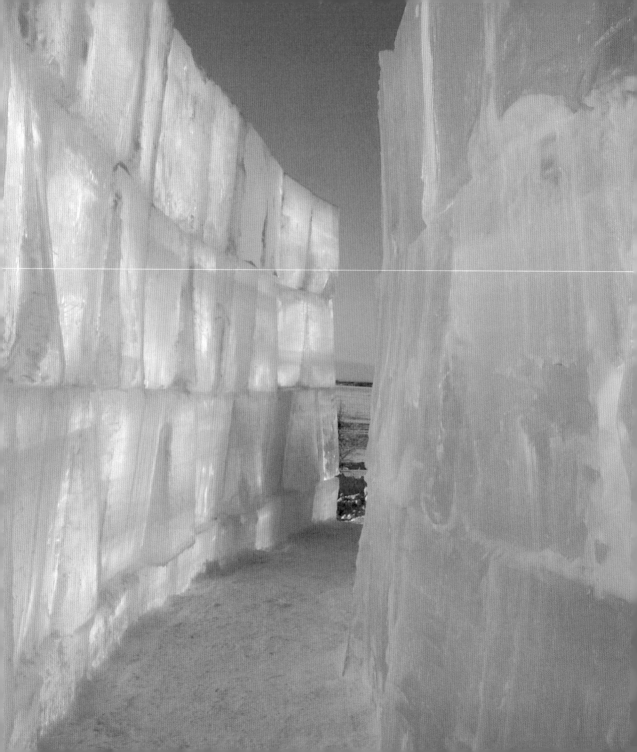

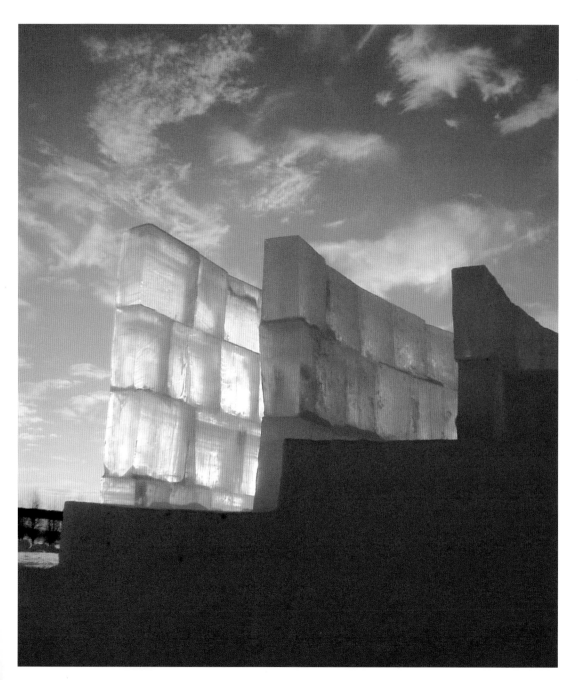

The Morphic Excess of the Natural/Landscape in Excess

Rachel Whiteread
Juhani Pallasmaa

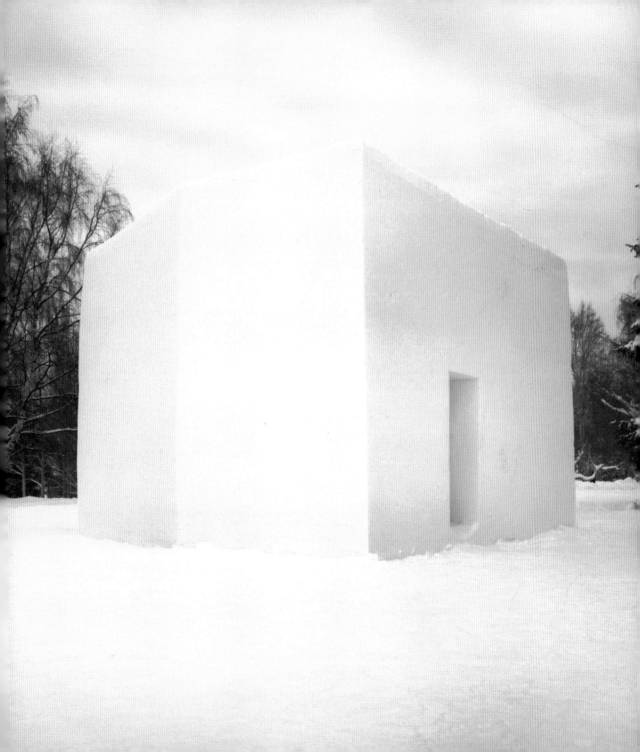

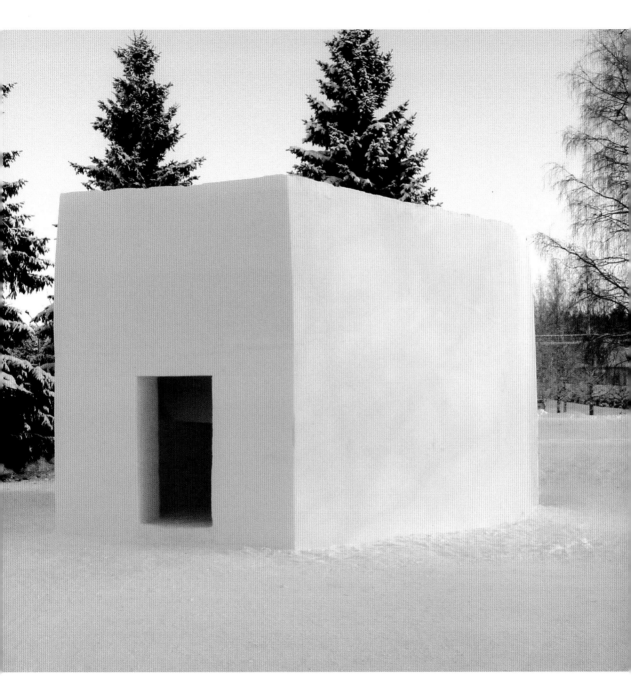

Untitled (Inside)

The artist's intended disorientation resulted
in a beautiful and engaging interior space.

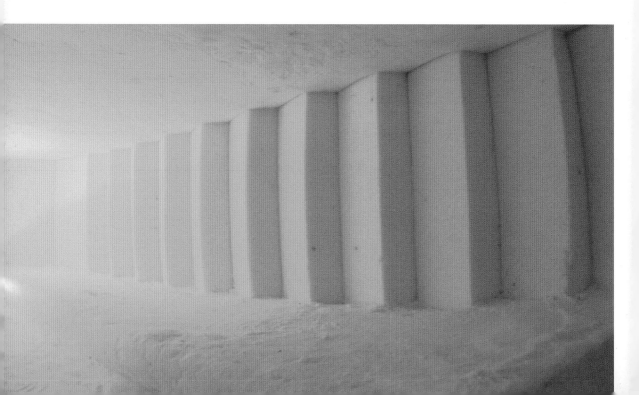

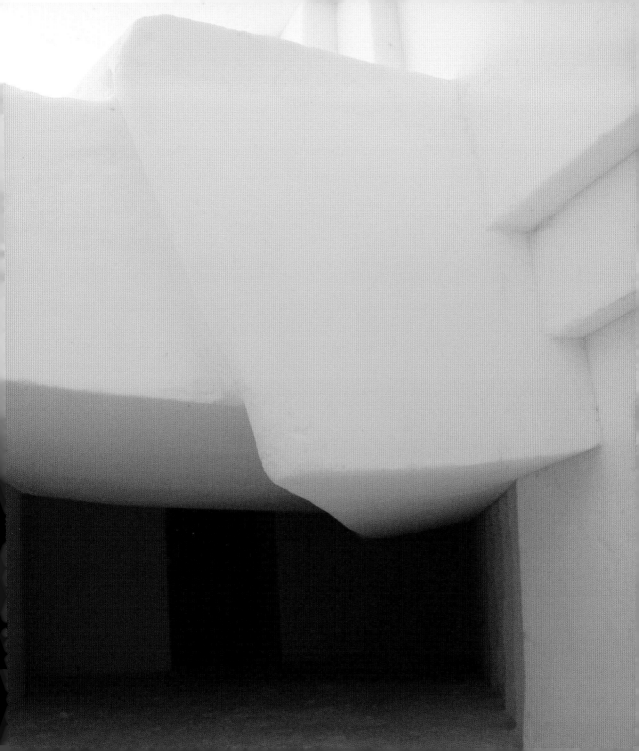

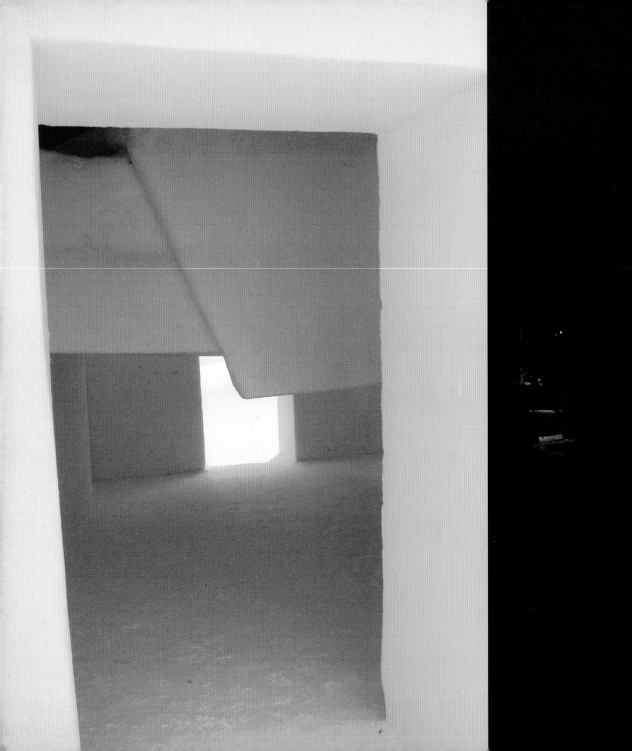

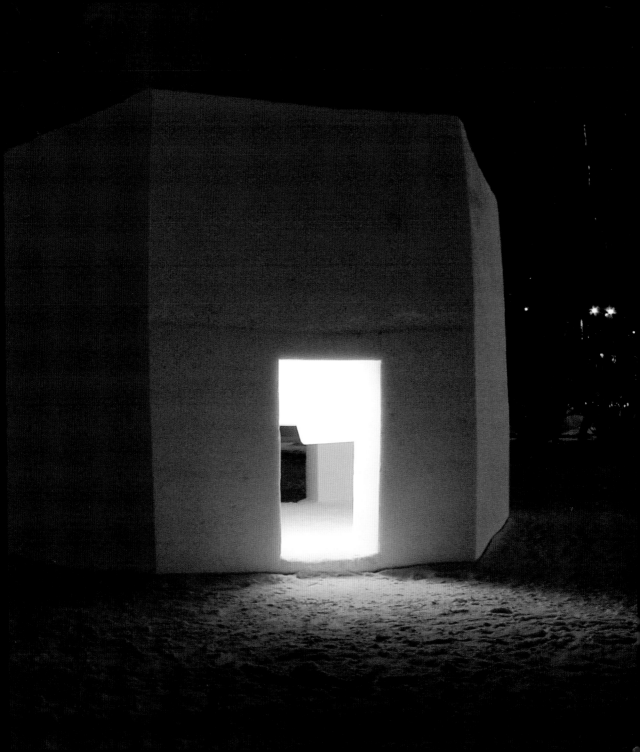

Robert Barry
Hollmén-Reuter-Sandman

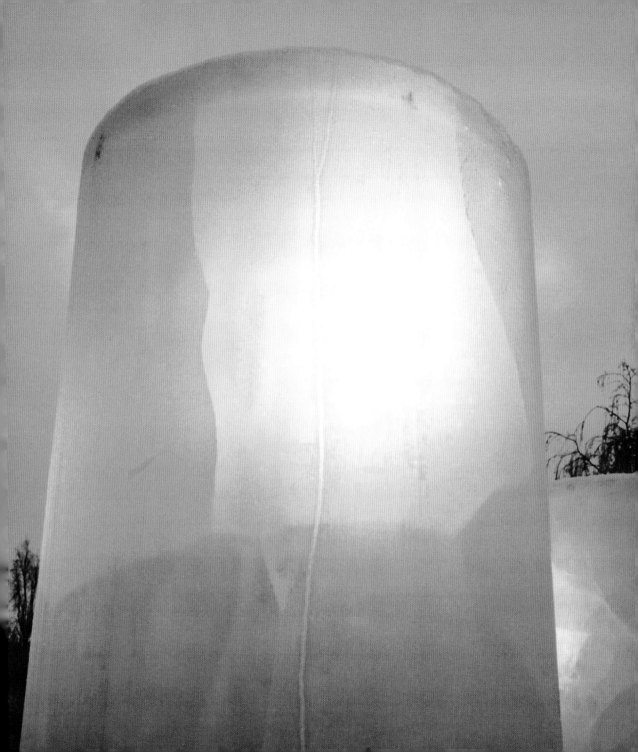

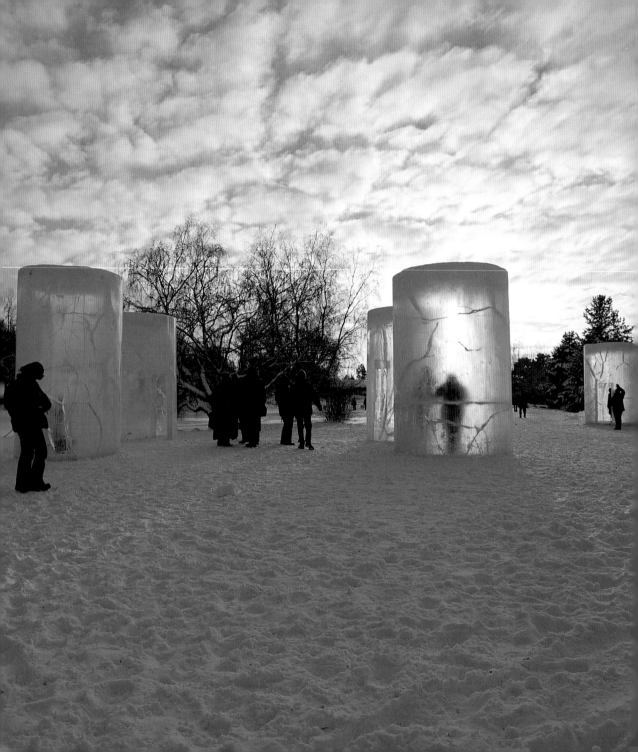

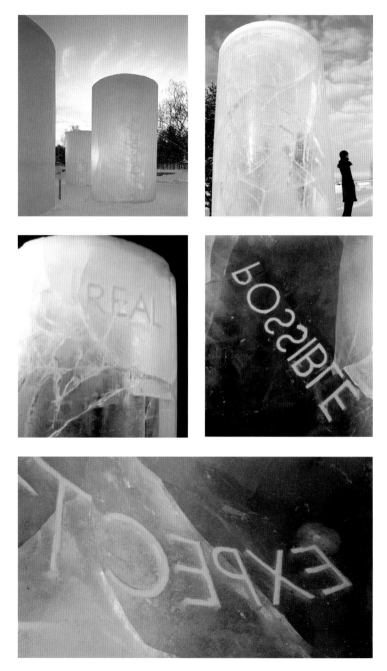

Lanterns of Ursa Minor

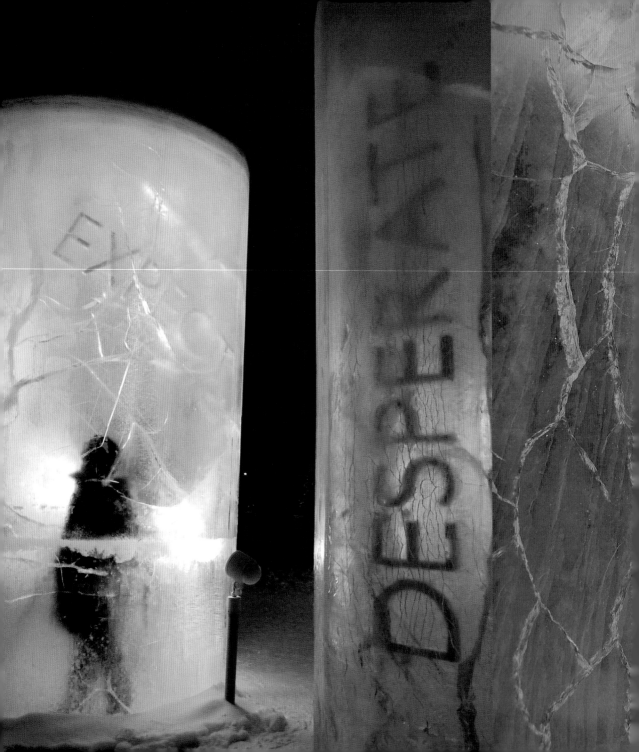

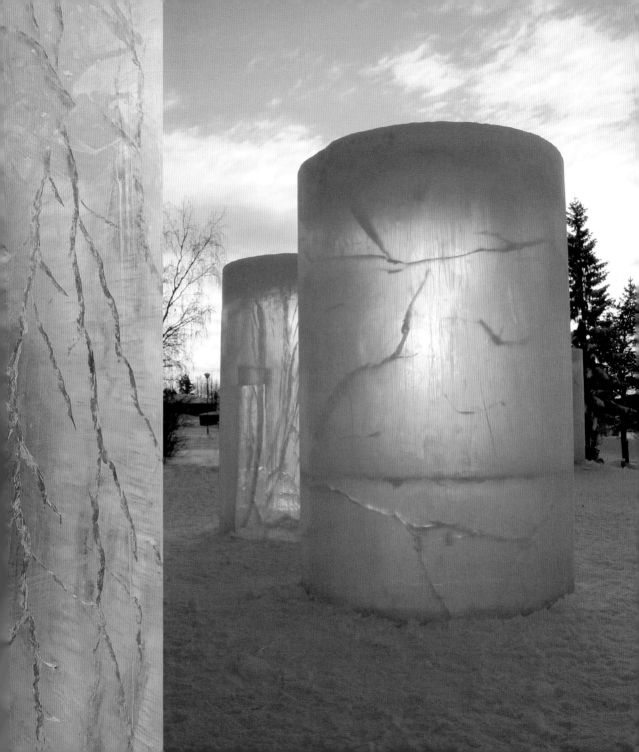

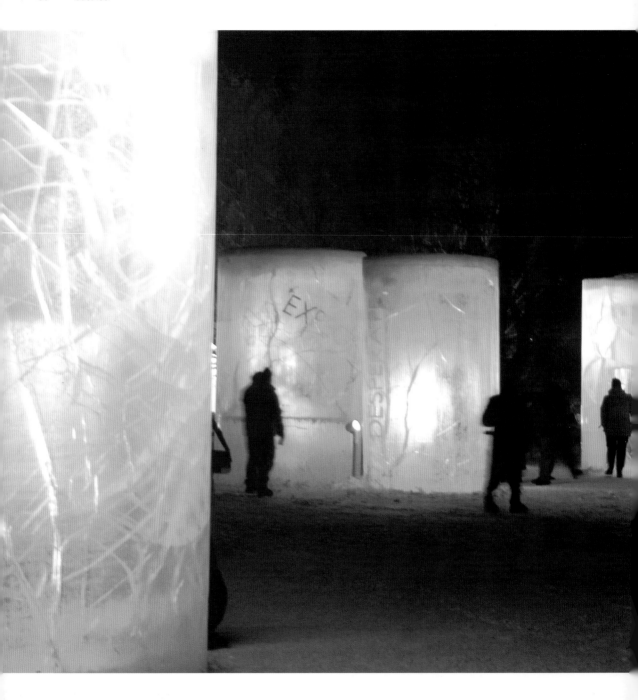

Rather than man making the object, Mother Nature did all the work. Conical forms, created during the freezing process, allowed the viewer to enter an intimate environment with microscopic views of ice formations.

Lanterns of Ursa Minor

Top Changtrakul
LOT-EK

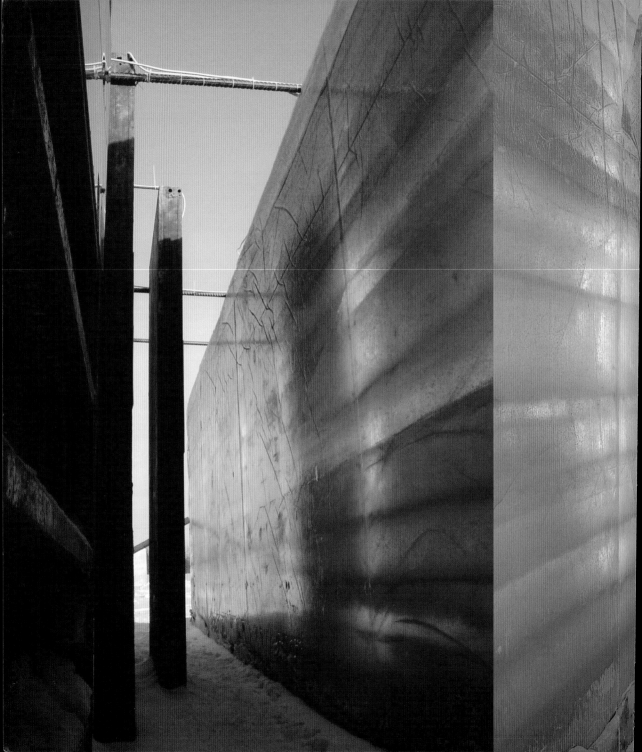

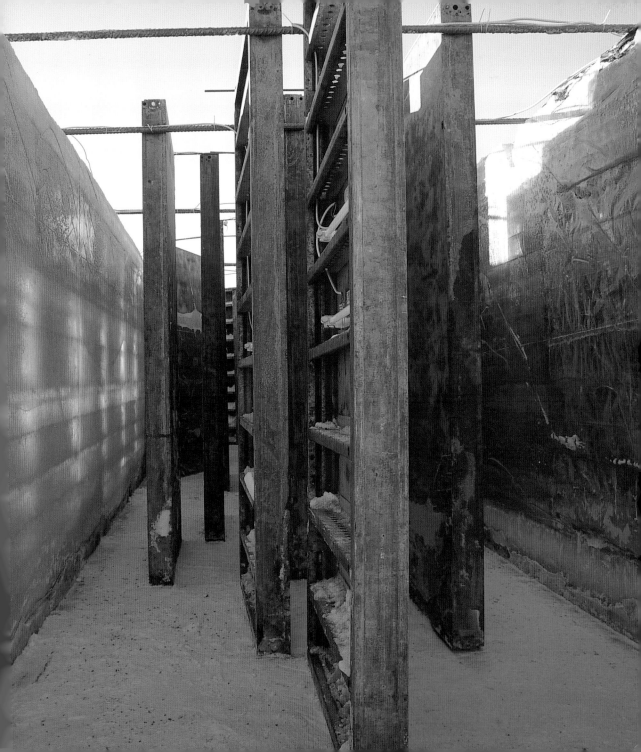

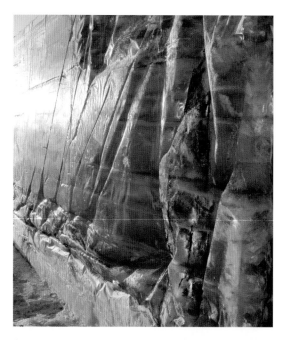

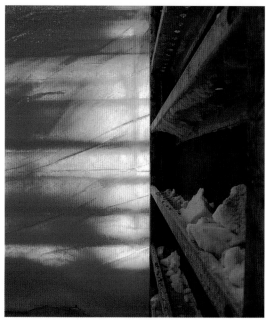
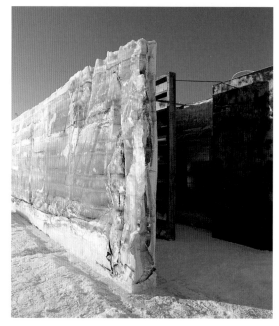

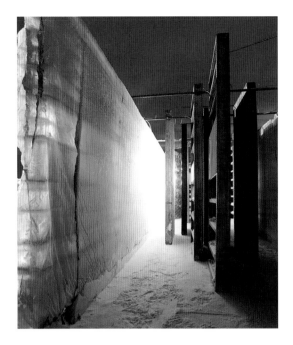

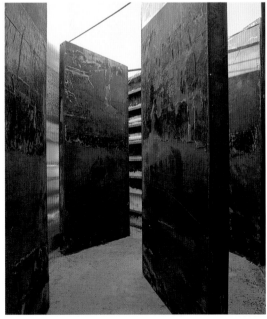

Coloured Ice Walls

Coloured Ice Walls

Ernesto Neto
Ocean North

Primarily interested in the natural freezing process, this team took pride in the fact that their experiment was still under way at the press opening, succumbing to natural forces and conditions.

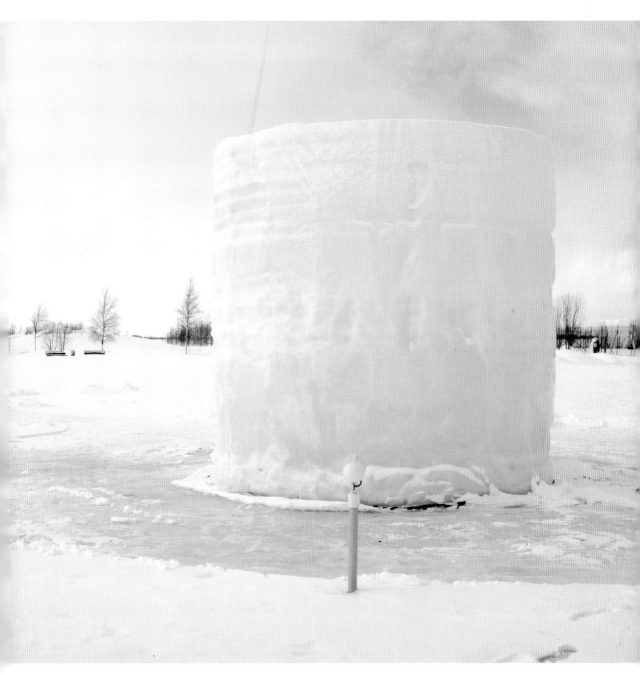

Frozen Void

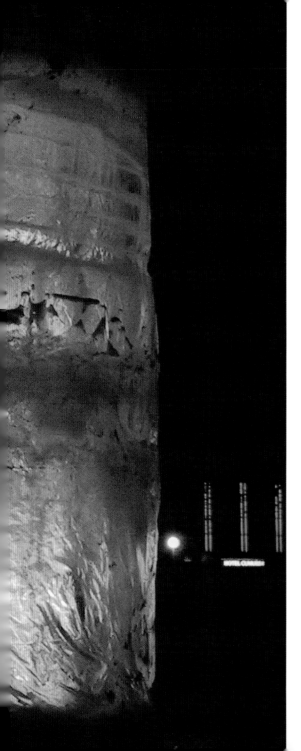

Frozen Void

Lawrence Weiner
Enrique Norten

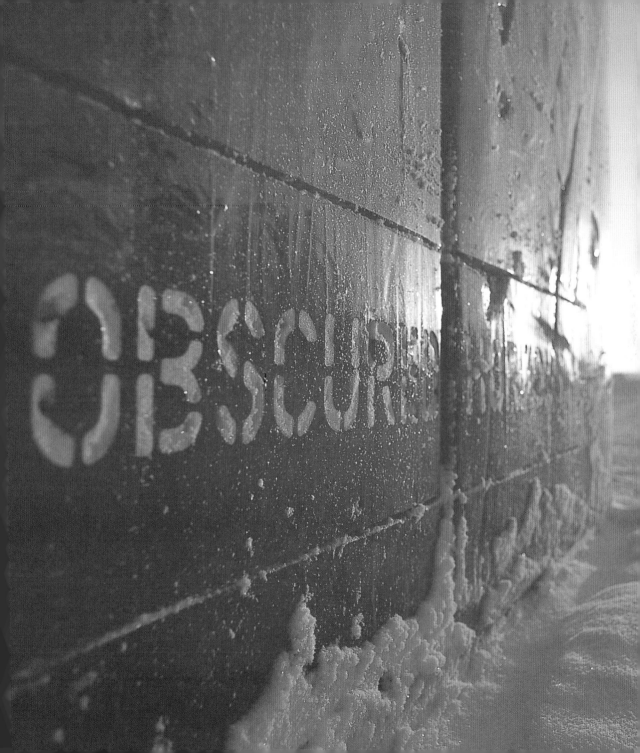

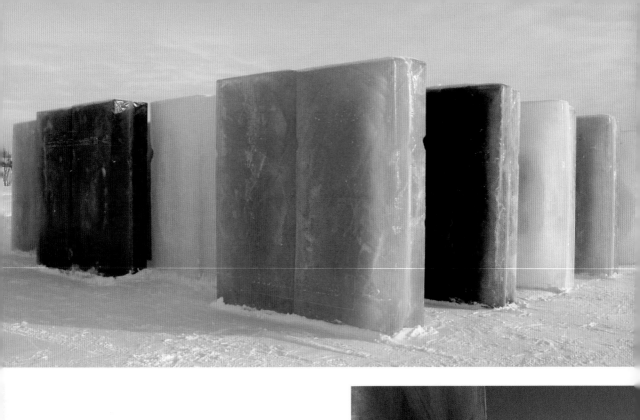

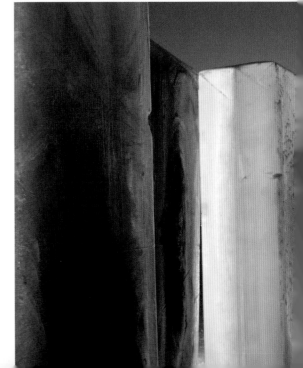

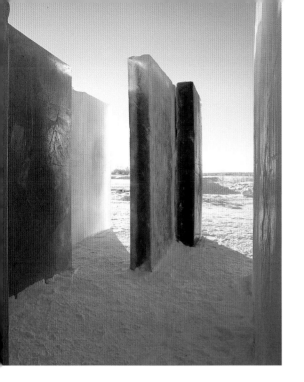

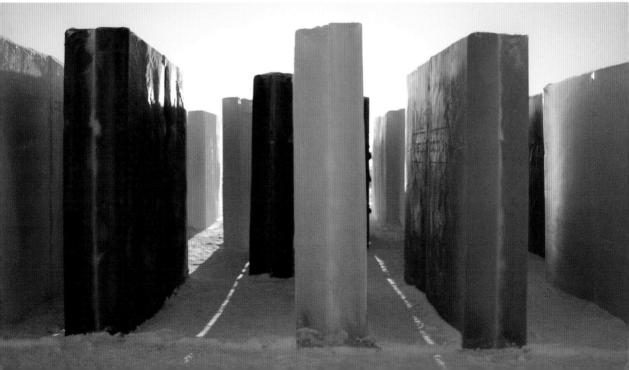

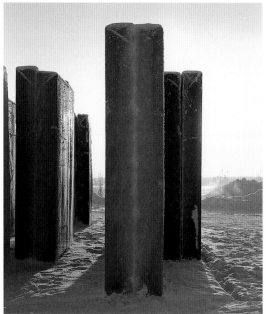

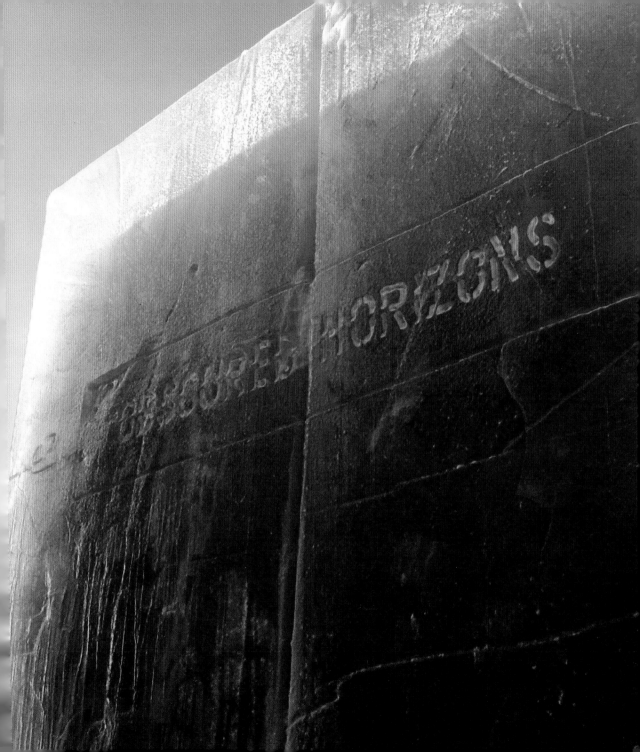

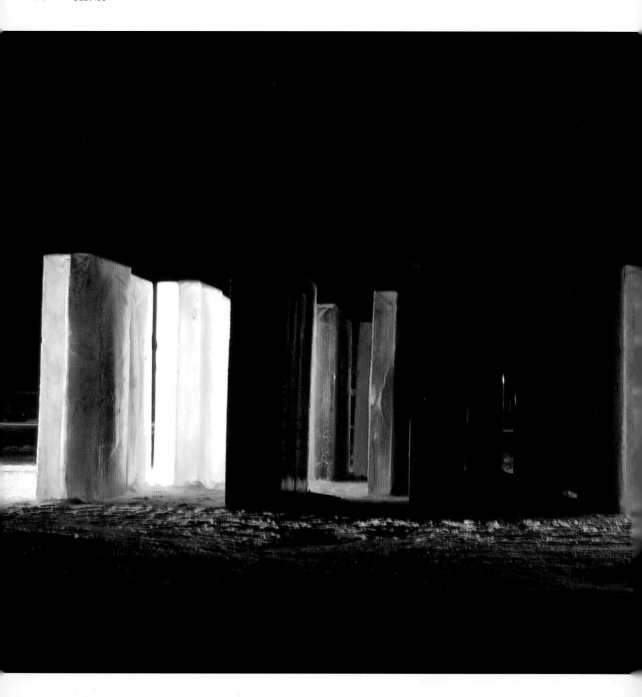

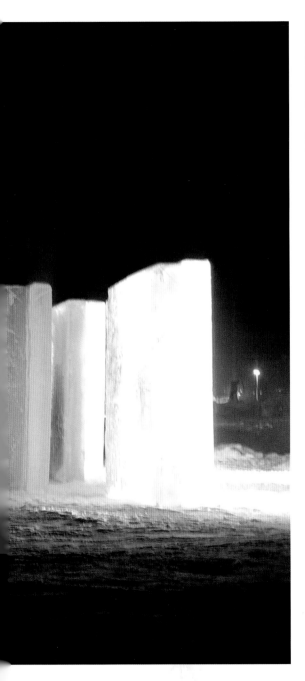

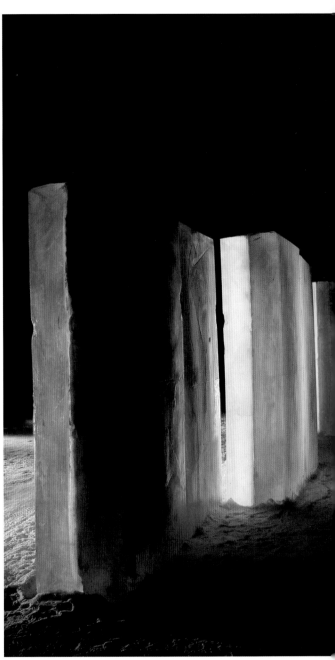

OBSCURED HORIZONS

Cai Guo-Qiang
Zaha Hadid

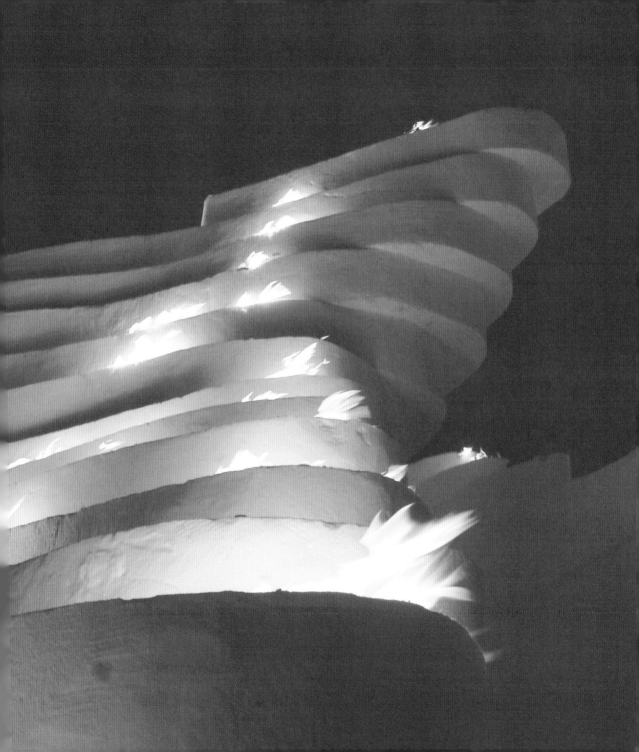

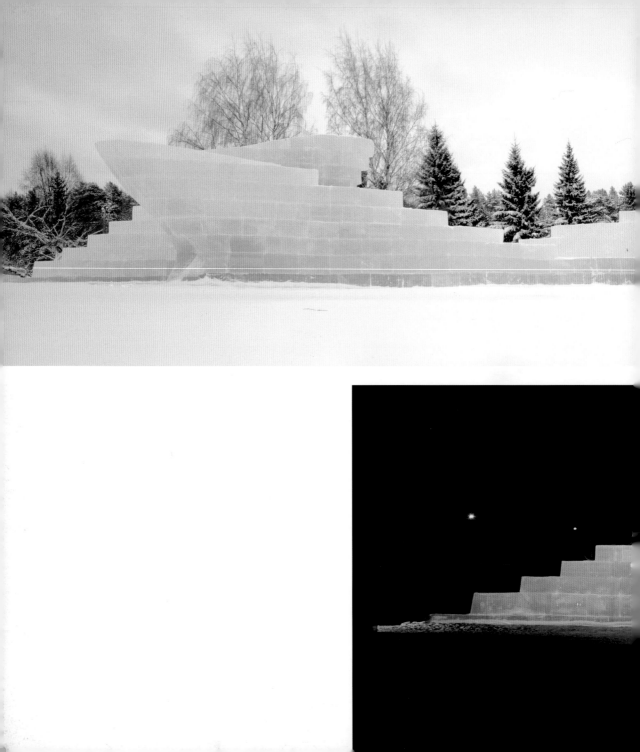

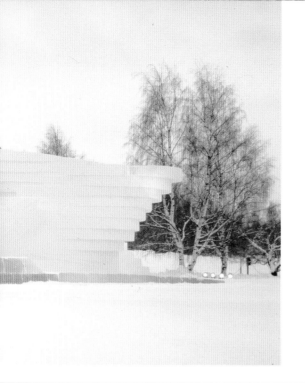

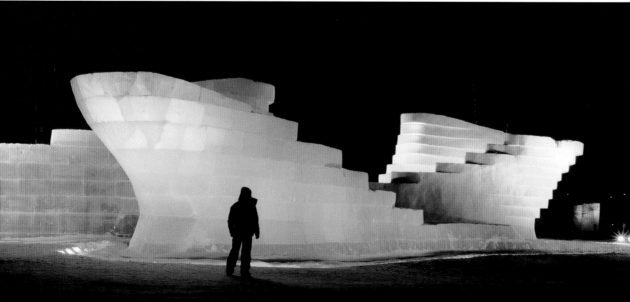

A pair of monumental frozen forms were enhanced only by their amazing partnership with fire. The piece truly came alive when the two contrasting elements converged.

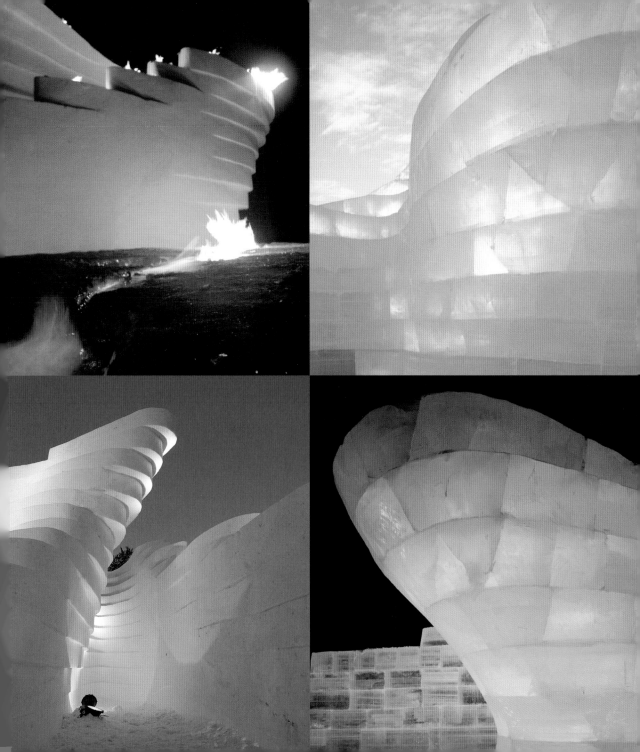

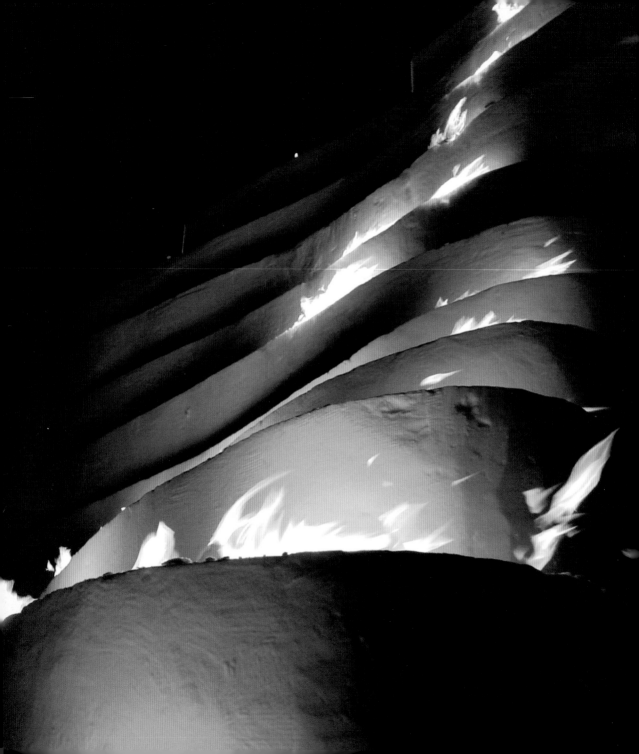

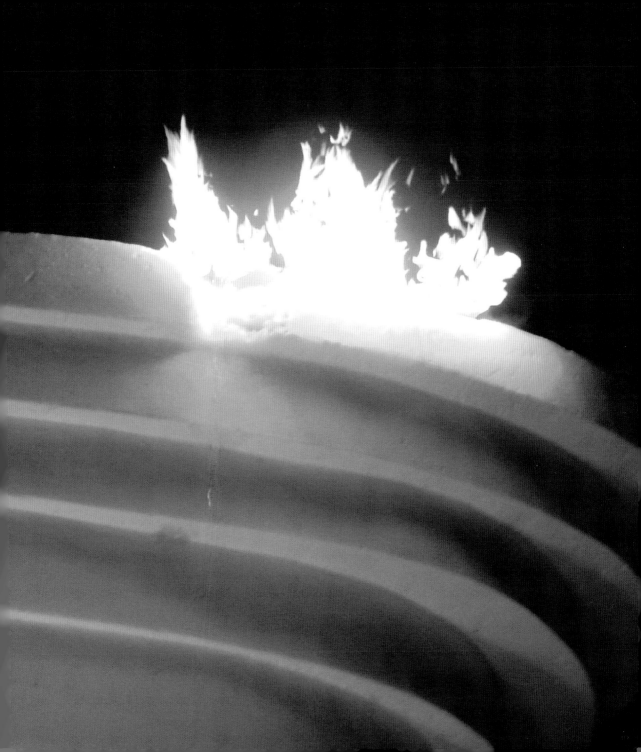

Jene Highstein
Steven Holl

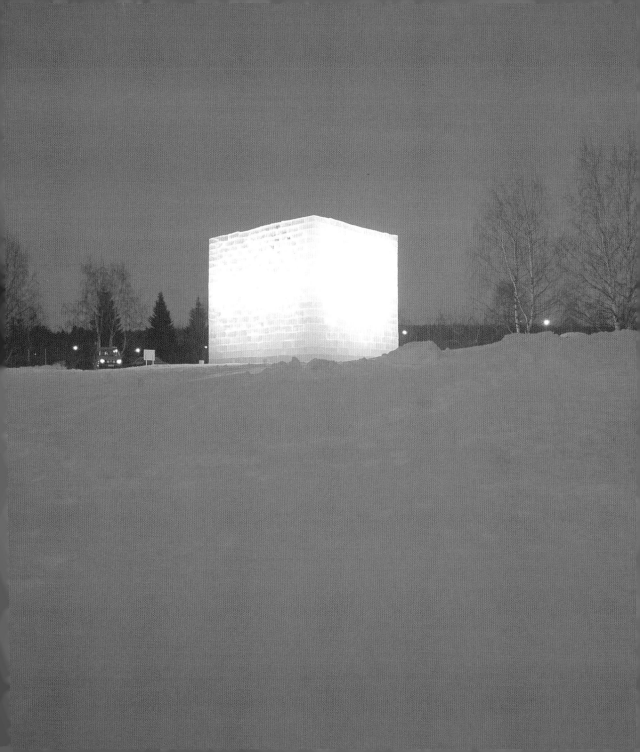

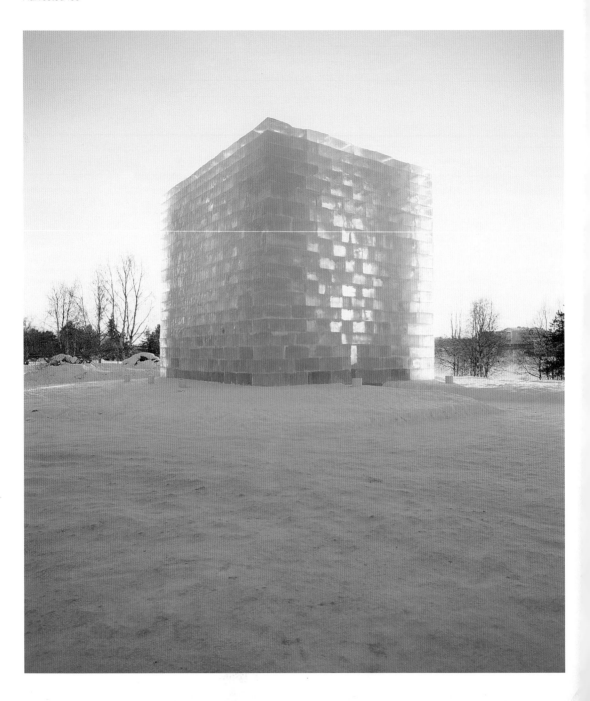

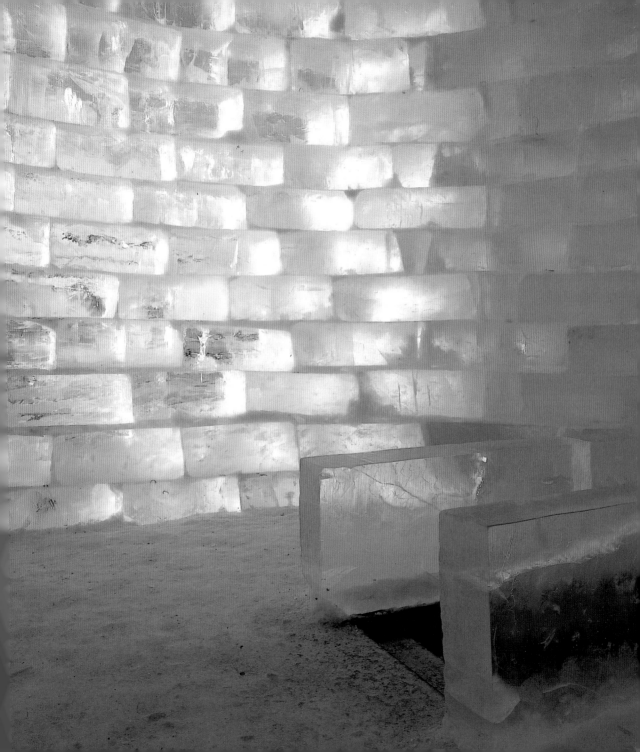

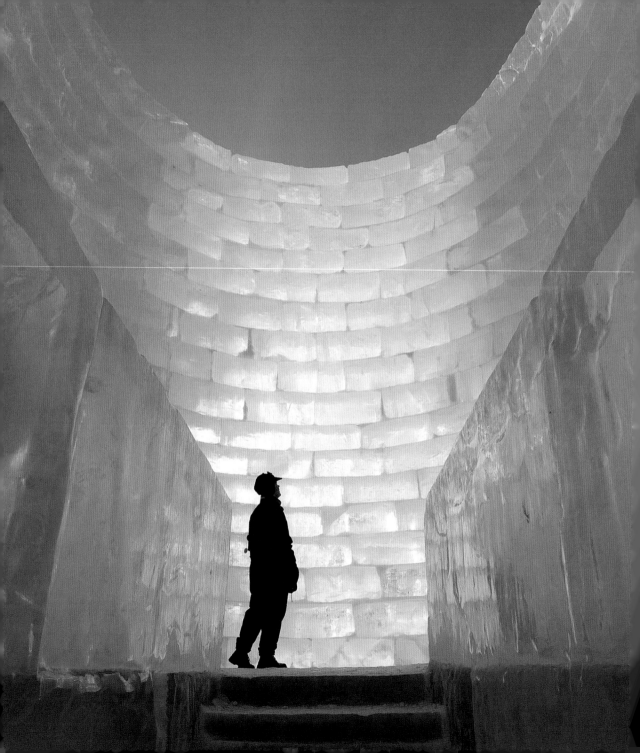

Concentrating on basic forms, such as the
cube and the sphere, optimized the beauty of
the harvested ice. The simple form transcended
art and architecture, creating pure wonder.

Oblong Voidspace

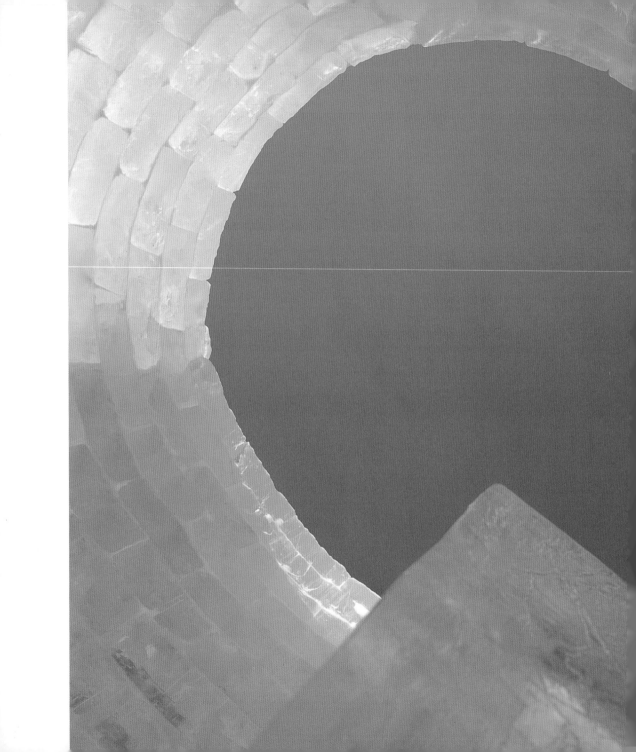

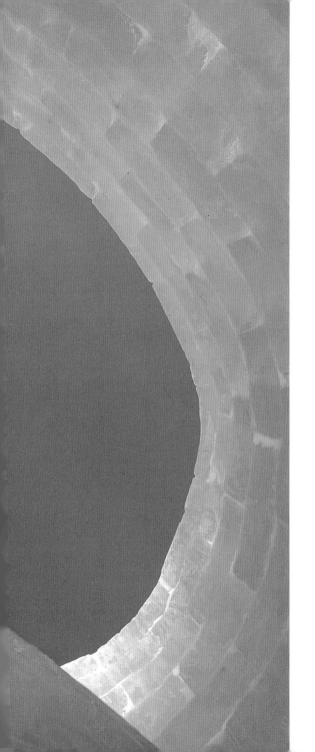

Oblong Voidspace

Tatsuo Miyajima
Tadao Ando

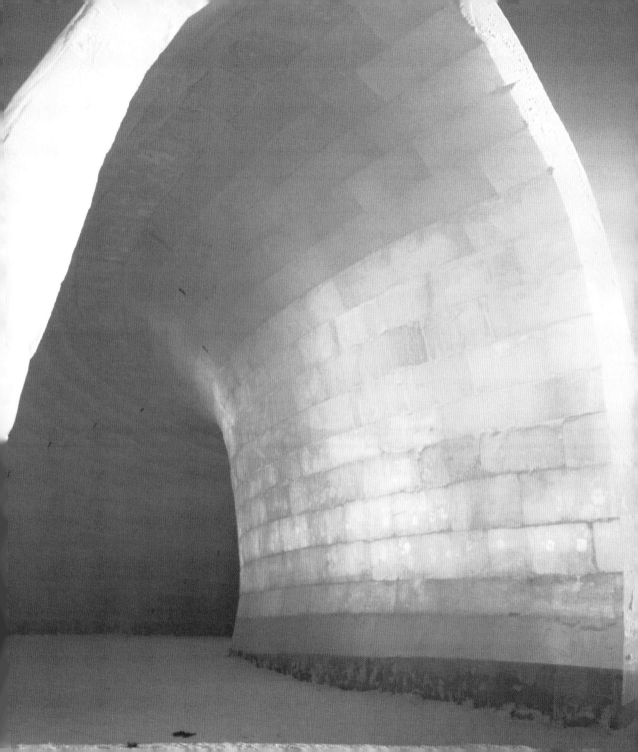

Raising issues of timelessness and spirituality, the
tunnel was a sublime fusion of art and architecture.

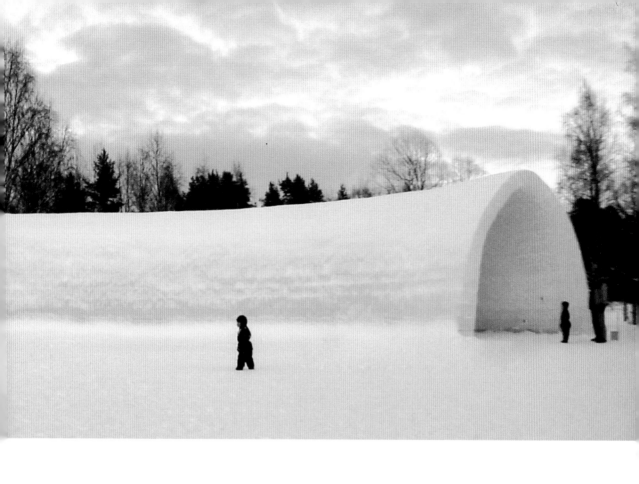

Iced Time Tunnel

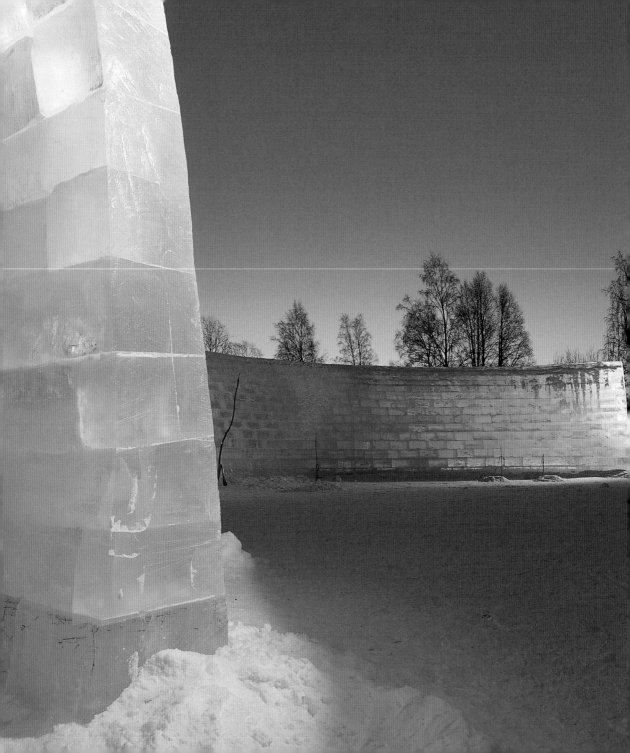

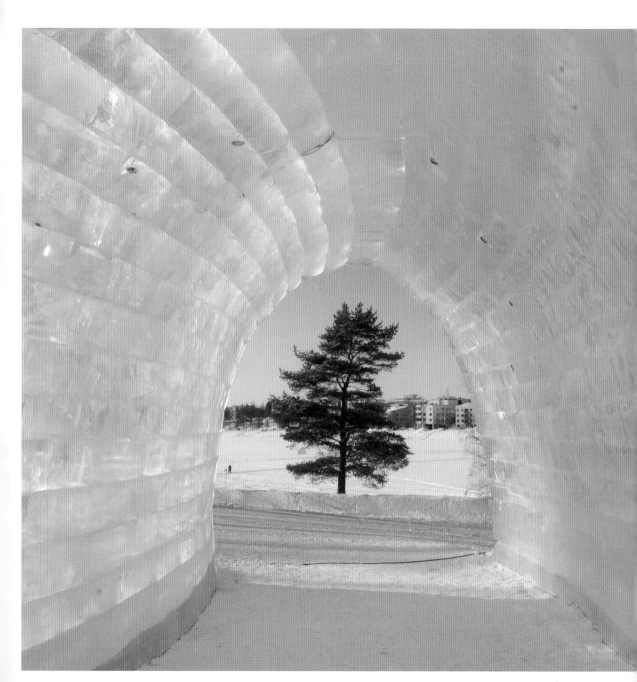

Iced Time Tunnel

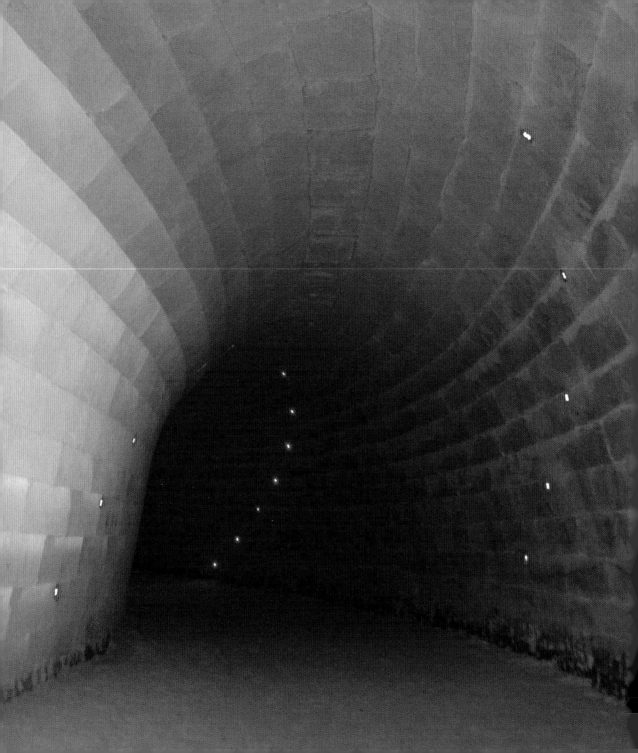

Yoko Ono
Arata Isozaki

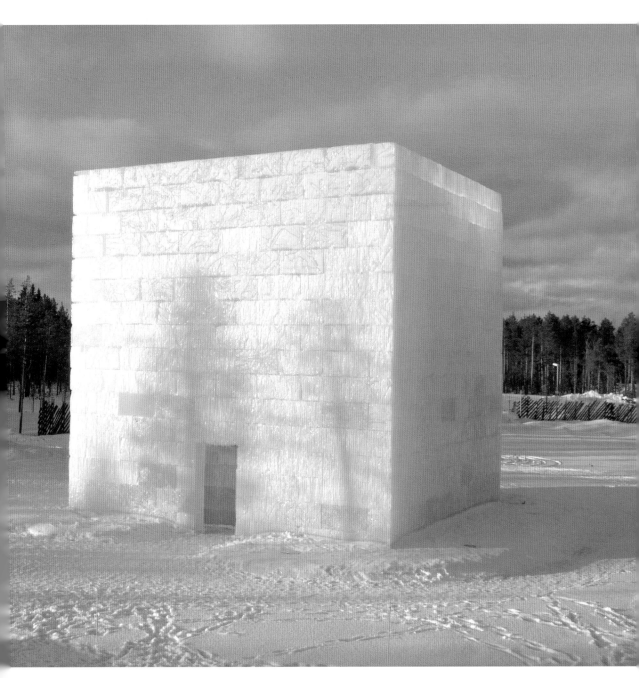

Penal Colony

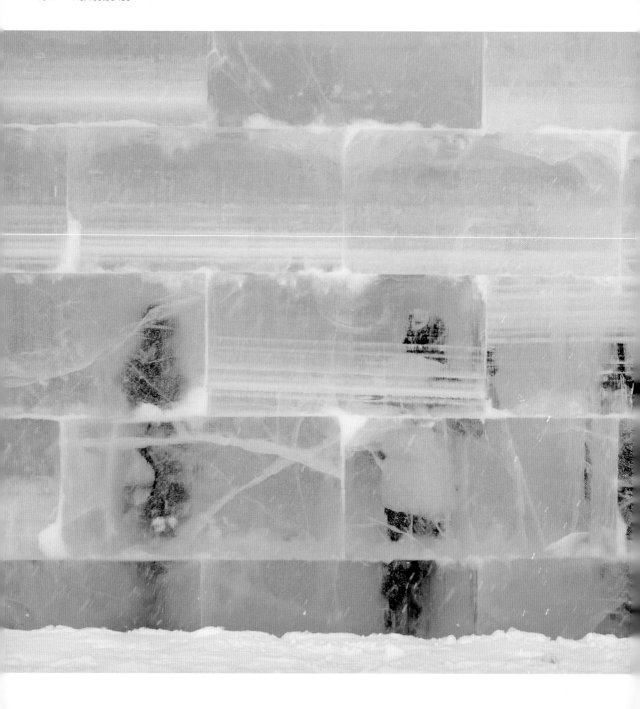

The physical labyrinth was a mentally disorienting enigma. When enclosed in the many layers of ice, visitors were struck again and again by the ghostly images of others, forcing them to look up into the sky to be free of the blue ice.

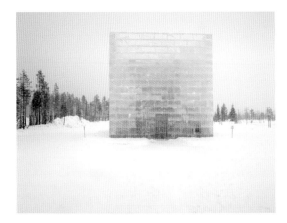

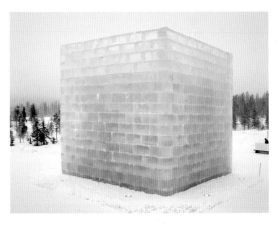

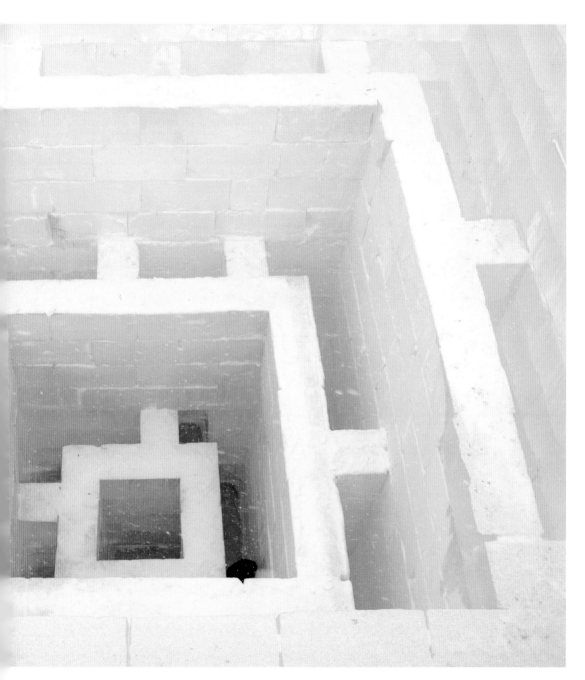

Penal Colony

Do-Ho Suh
Morphosis

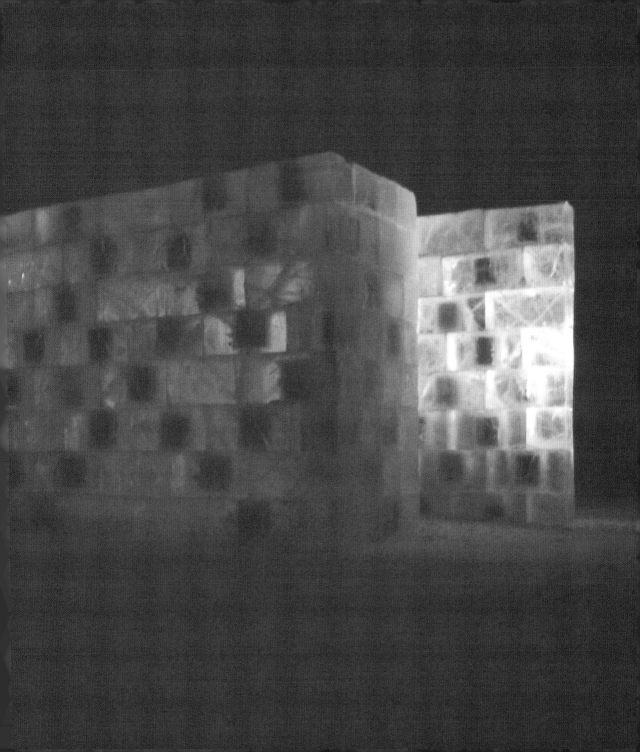

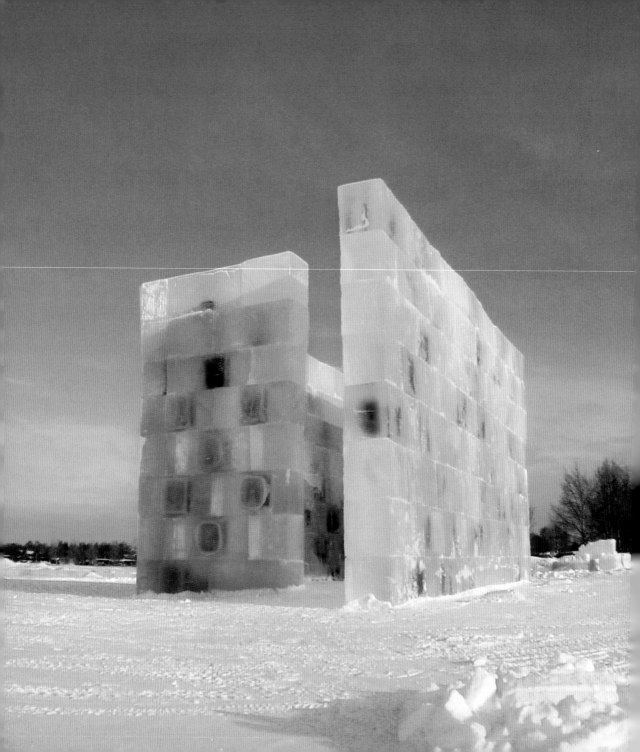

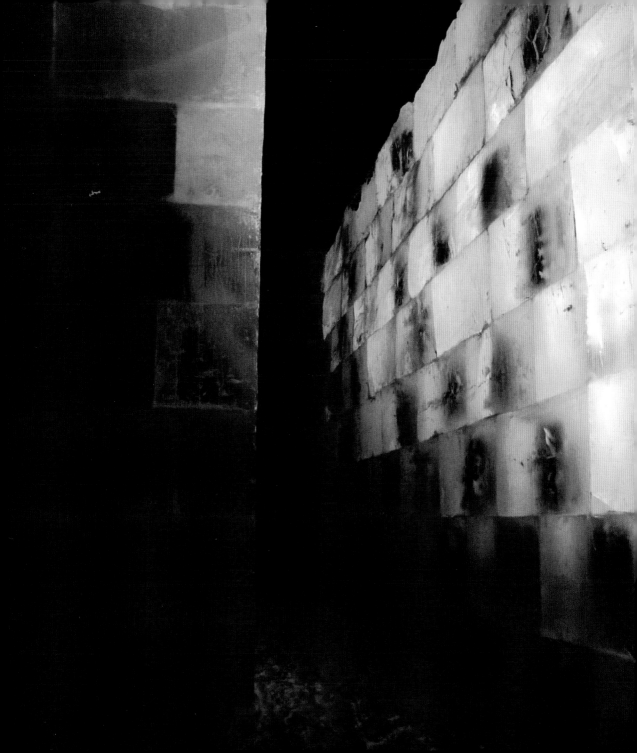

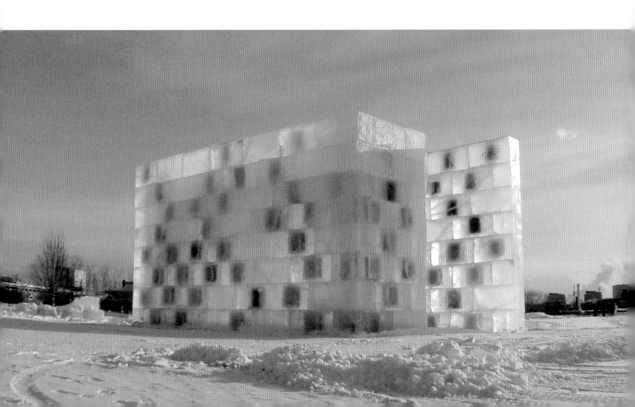

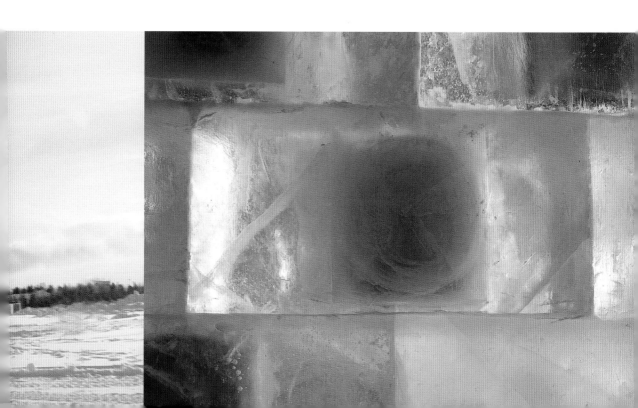

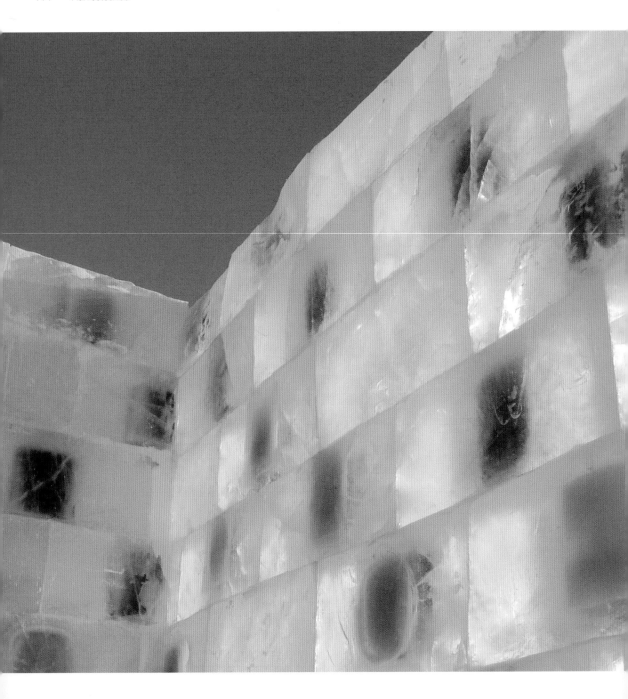

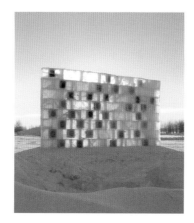
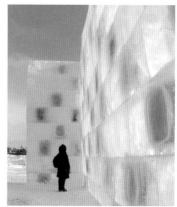
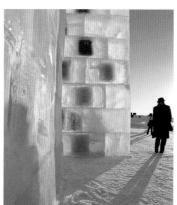
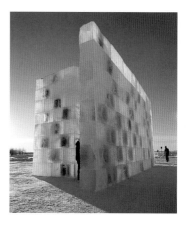

Fluid Fossils

Lothar Hempel
Studio Granda

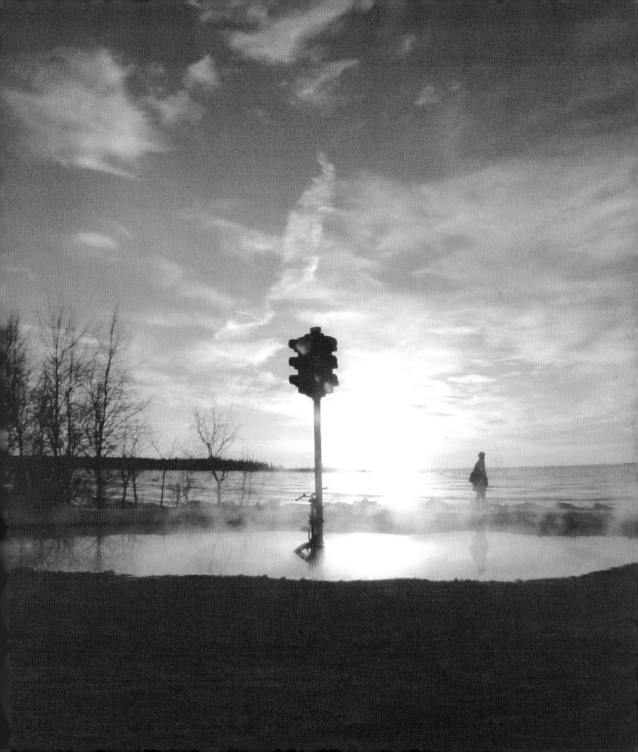

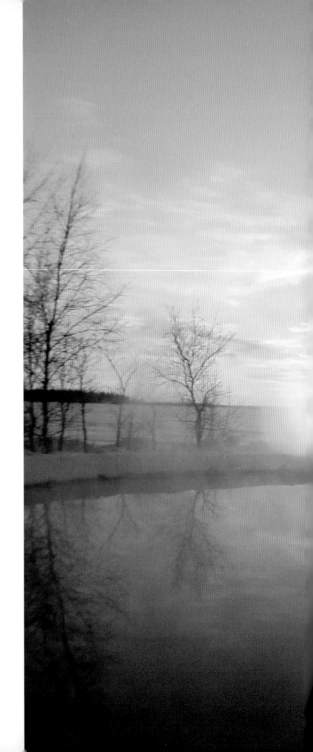

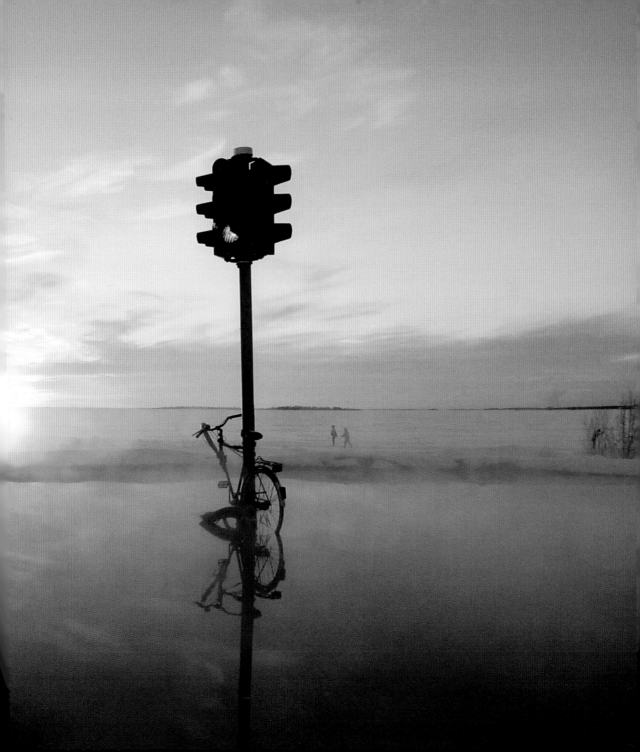

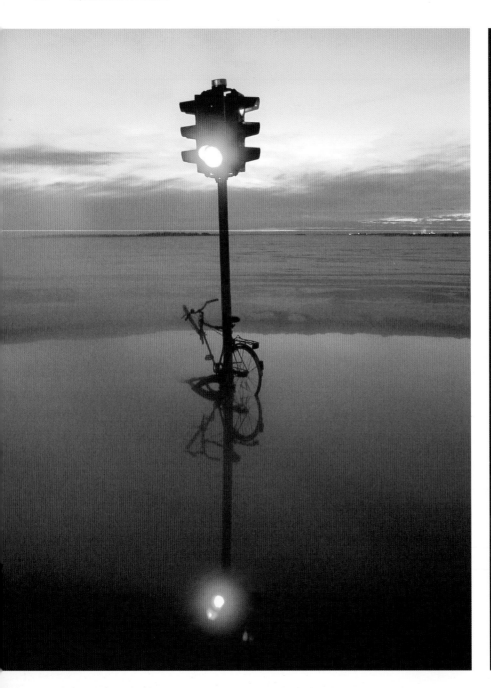

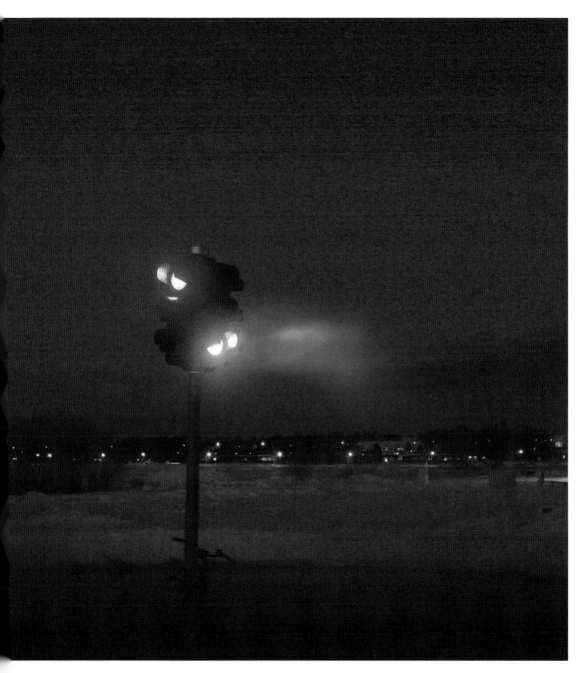

Katzenauge/Catseye

A modern-day traffic light created a unique vignette. As steam rose from the surrounding pool, it coated the adjacent trees with crystalline formations alluding to the cyclical nature of air, water and ice.

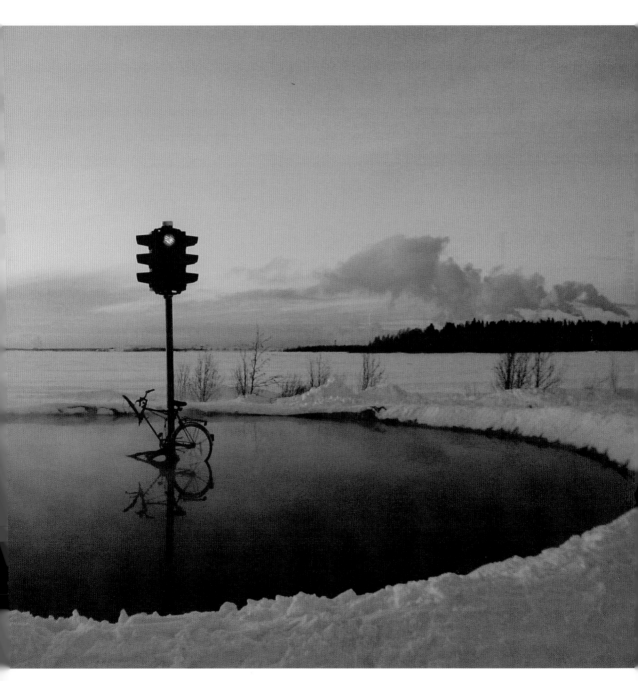

Katzenauge/Catseye

Anish Kapoor
Future Systems

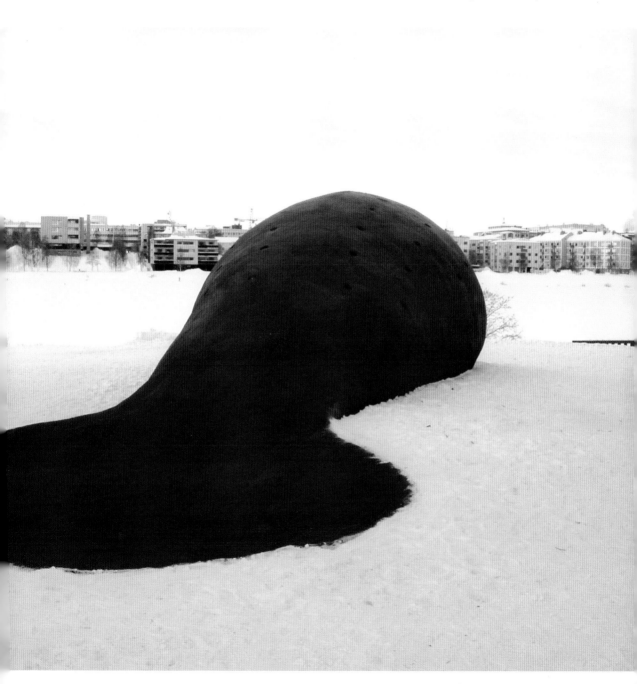

Red Solid

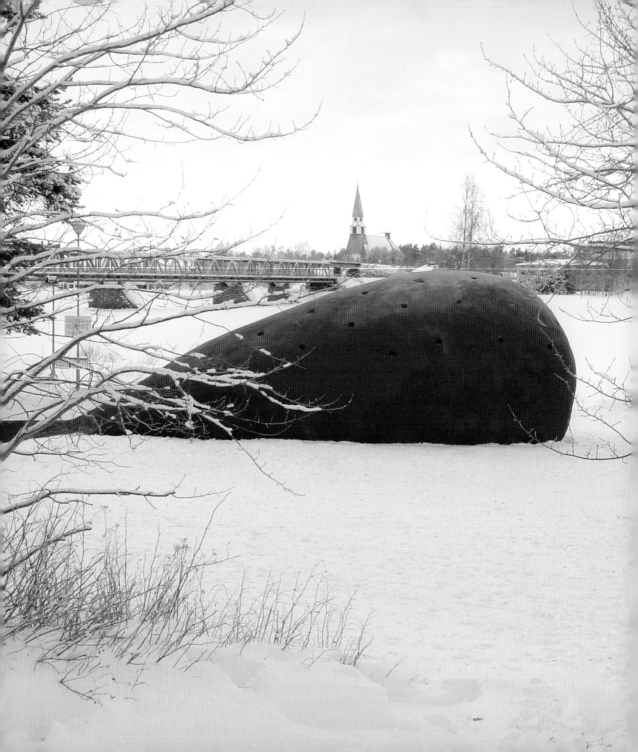

This team challenged the building process with
an unusual form and a vibrant colour.

John Roloff
Diller + Scofidio

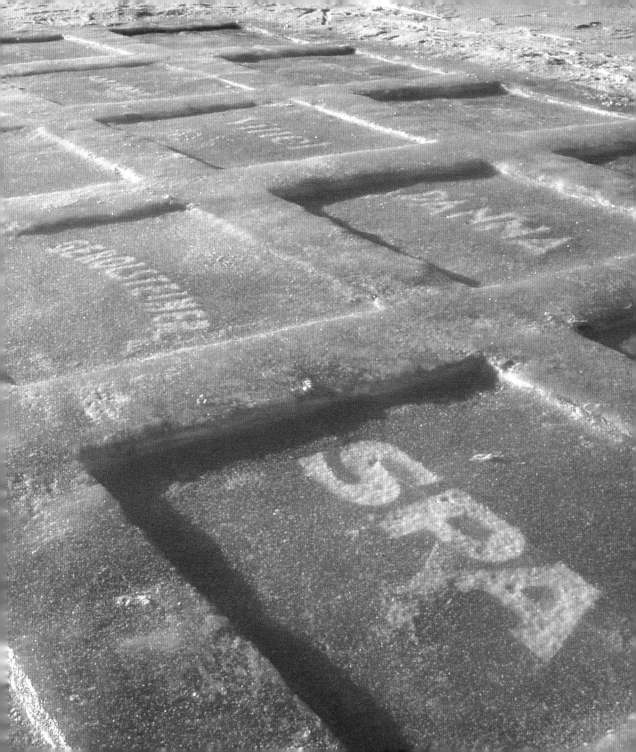

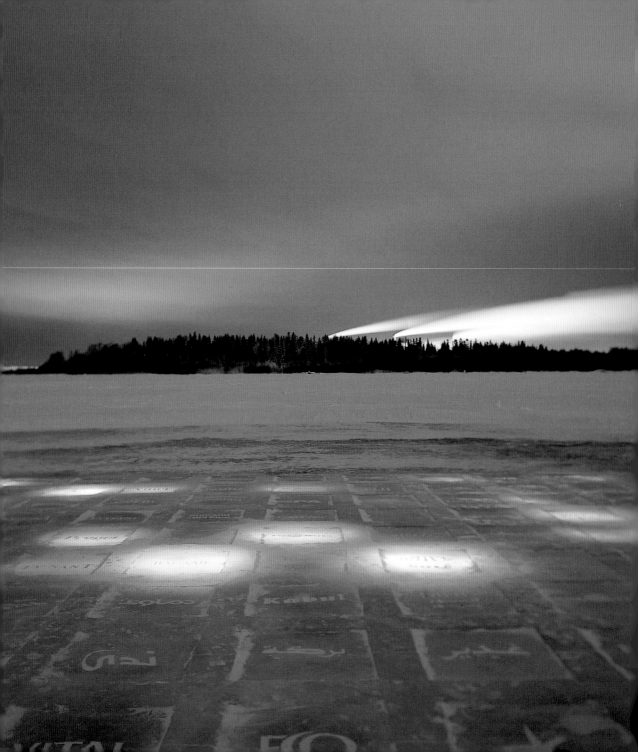

GOLD
SPRINGS
Serenity

blue

HIMALAYAN

Nestlé
نستله

DeepSea Water

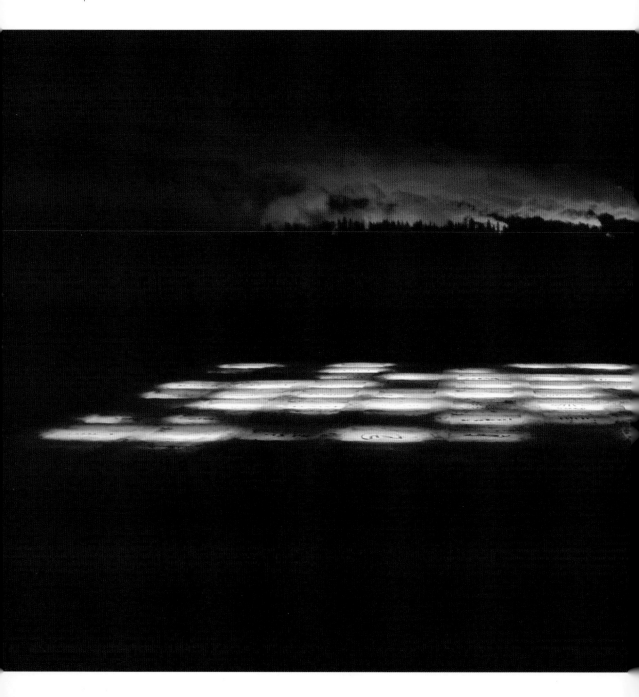

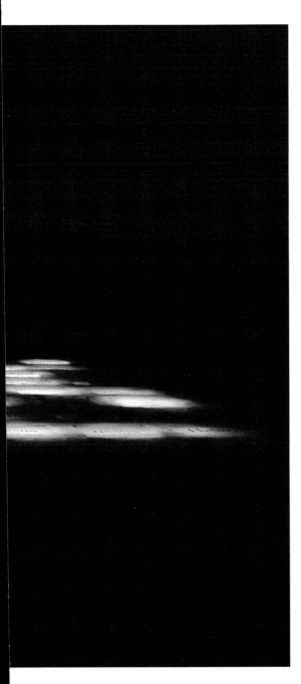

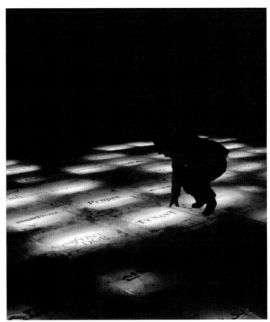

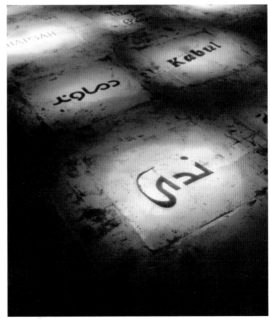

Pure Mix

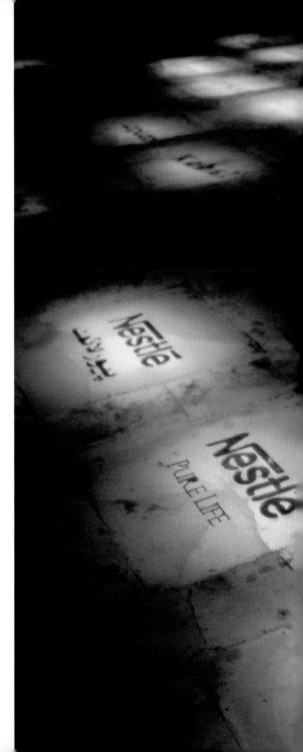

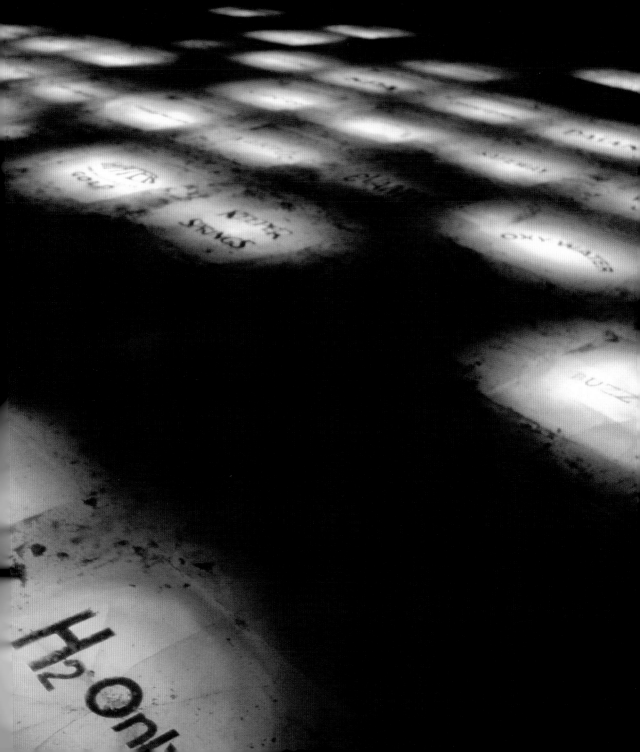

Kiki Smith
Lebbeus Woods

In the daytime, the work's hard flatness concealed its depth. However, in the darkness of the arctic winter, the art appeared: lights illuminated layers of soft images and unfamiliar silhouettes.

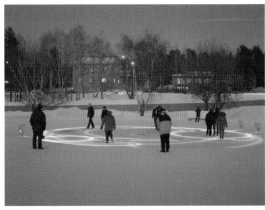

Skypool

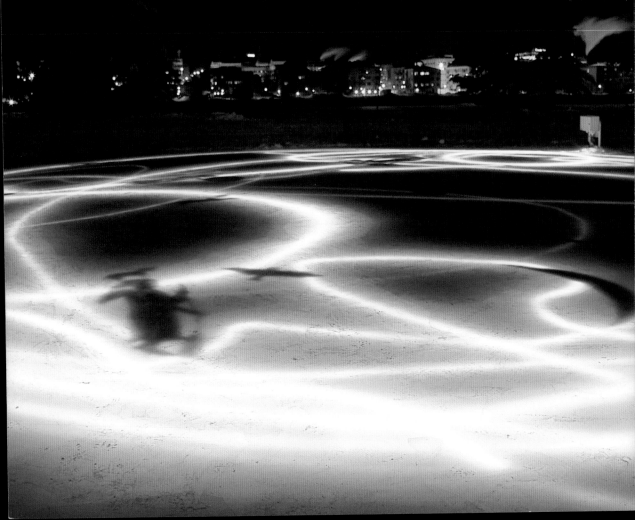

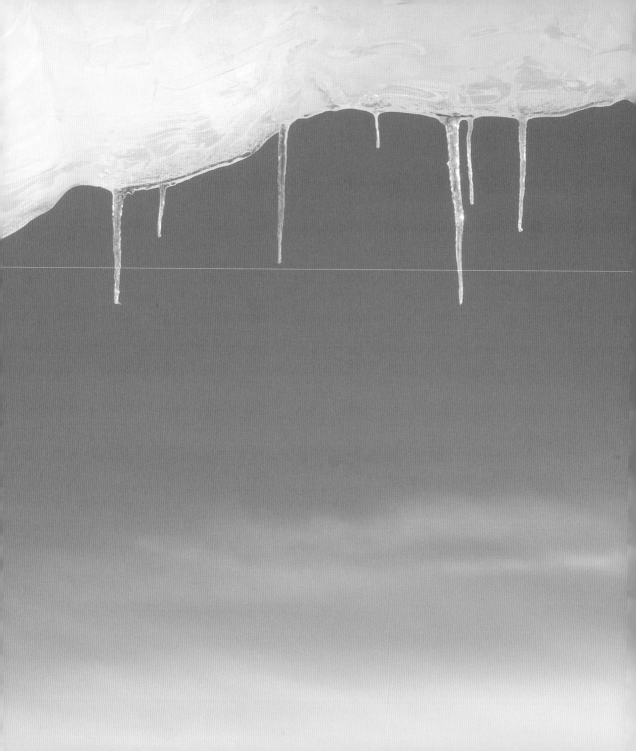

Methods and Process

Compacted Snow

Carsten Höller
Williams & Tsien

Osmo Rauhala
Asymptote

Eva Rothschild
Anamorphosis

Rachel Whiteread
Juhani Pallasmaa

Building with snow and ice is essentially working with water. These natural materials are unpredictable and alive. As a result, they were in constant flux from before the work began until each project's final moments. The building process was similar for all four compacted snow constructions. Two moulds were required: an exterior one to define the outer shape of the structure and an interior one to form the shape of the inside space. In most cases, the moulds were plywood constructions built on site. Once both moulds were in position, snow was piled up and then blown into the moulds. After a significant amount of snow had been blown into the formwork, it was compacted to increase its density and new snow was blown in. This process continued until the entire exterior mould was filled and compressed.

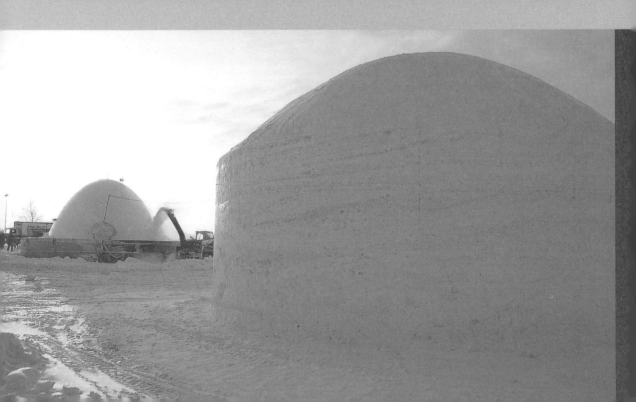

Previous spread: Carsten
Höller and Williams & Tsien,
Meeting Slides.

Opposite: Osmo Rauhala
and Asymptote, *Absolute
Zero: A Light House of
Temporality*.

Below: Rachel Whiteread
and Juhani Pallasmaa,
Untitled (Inside).

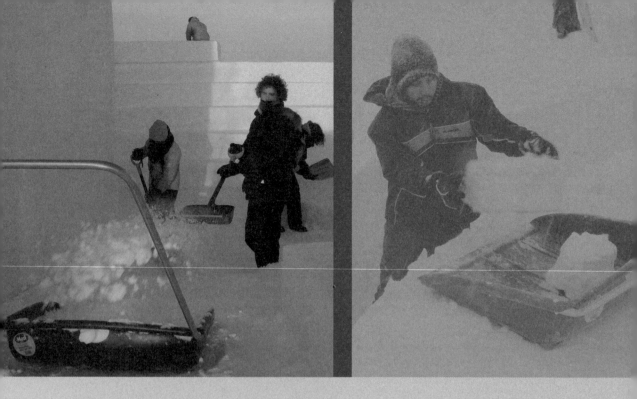

Snow does not take long to set and a mould can be
removed within hours of packing to reveal a fully
compacted form. To distinguish the final design from
the rough form, the compacted snow was sculpted
with hand tools to achieve the desired shape and
quality. Snow hardens very quickly in normal winter
conditions, and compacted snow can be loosely
compared to the hardness of concrete. Chisels,
chain saws, shovels and hand sanders were among
the tools used to carve the structures.

An alternative to the plywood interior mould
was used by Osmo Rauhala and Asymptote, whose
design was based around two enormous domes.
The wooden moulds could not be constructed in the
necessary shapes, so two air bladders defined the
space. As with the wooden moulds, the air bladders
were covered with the compacted snow, but instead

Far left: Eva Rothschild and Anamorphosis, *The Morphic Excess of the Natural/Landscape in Excess*.

Left: Carsten Höller and Williams & Tsien, *Meeting Slides*.

Right: Rachel Whiteread and Juhani Pallasmaa, *Untitled (Inside)*.

of the deconstruction process needed with wood, the bladders were simply deflated leaving a cavity that was true to the design and required very little smoothing.

The interior of Rachel Whiteread and Juhani Pallasmaa's design incorporated flat expanses of snow, which are normally quick to slump and sag. As in a concrete construction, rebars prevented the inevitable sagging and strengthened the span.

For the two other projects – by Carsten Höller and Williams & Tsien and Eva Rothschild and Anamorphosis – laser surveying equipment accurately measured the angles and corners of the designs. After the snow was packed and the moulds removed, points were entered into the lasers, which then determined the exact amount of carving needed at a specific location on the structure to create the final shape.

Carsten Höller
Williams & Tsien

Meeting Slides

Ten curved slides brought passengers down to a sunken plaza. Some slides met on their way down, and all slides met in the plaza, which was lit from underneath.

Carsten Höller

We believe that architecture is the coming together of art and life. It is a container for experience. Rather than making this container an object, we decided to dig down and make it only about space.

Path and movement are intrinsic to a plan. This was a plan that was pure circulation, but circulation that was fun. Sliding down, losing control, laughing and climbing out. The path was mysterious, but the destination was clear.

Billie Tsien, Tod Williams

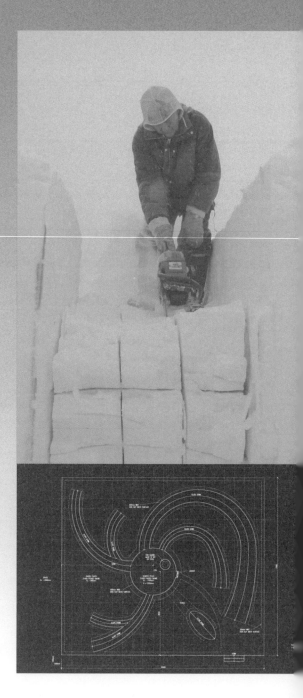

Top right: Cutting out the slide's pathway.

Bottom right: Site plan, Williams & Tsien.

Far right: Finishing the exterior.

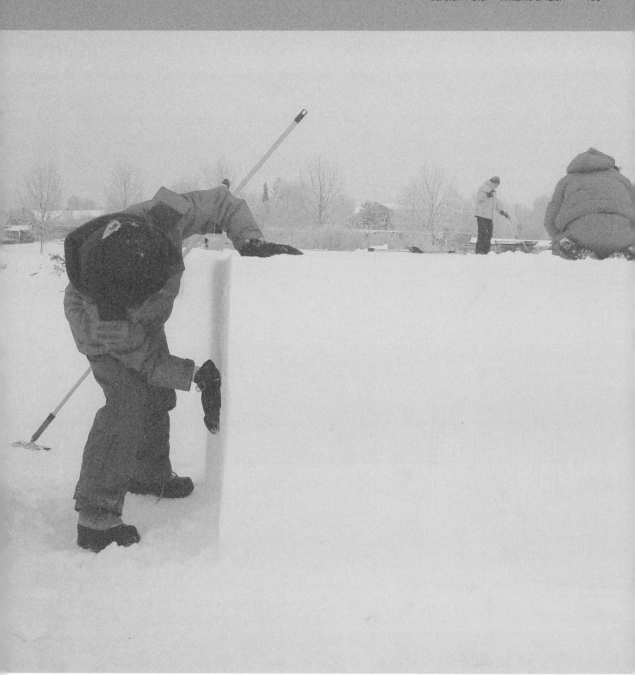

Osmo Rauhala
Asymptote

Absolute Zero:
A Light House of Temporality

The third law of thermodynamics states:
'There is no disorder in a substance in equilibrium at the absolute zero of temperature.'

As artists and thinkers we can visit and comment on the notion of order as it pertains to our tenuous relationship to nature outside the scientific debate. From this position, we can propose possibilities that are tangible realities tethered precariously to the human condition.

This work strove to harness the forces of nature and to manner them into a physical inhabitable environment. The 'architecture' and its resultant interiority communicated through traditions as old as story telling and ideas as advanced as engineering and mathematical theorems (determined by natural systems and orders). Existing on the edge of these phenomena, the work attempted to reveal simultaneously contemporaneous and traditional views on the eternal human-technological-natural-environmental condition that is indisputably a global state of great concern.

Asymptote

Top left: Snow blown onto the air bladders.

Top centre: 3-D computer rendering, Asymptote.

Top right: Elevation, Asymptote.

Right: 3-D computer rendering, Asymptote.

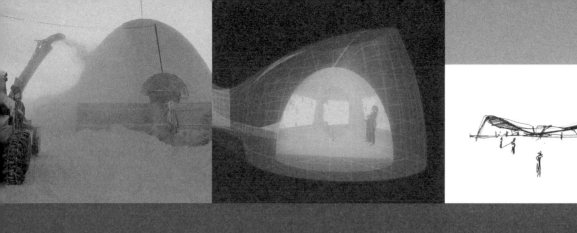

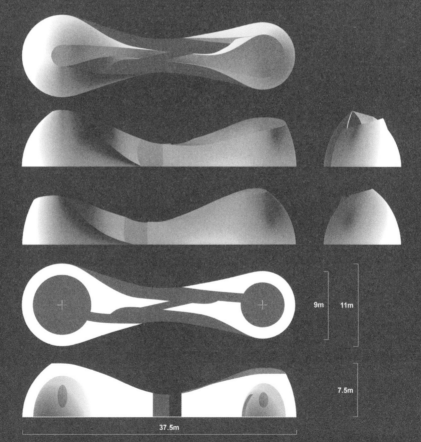

9m 11m

7.5m

37.5m

Eva Rothschild
Anamorphosis

The Morphic Excess of the Natural/ Landscape in Excess

Anamorphosis and I share certain interests and principles: we are both interested in the kinaesthetic and psychic interaction we can have with a space or an artwork; how we move within a constructed environment; and the possibilities of enabling the individual to inhabit a space in an expansive way, where the focus is on the actual experience of being there. Snow and ice interest me as materials because they have no value, they are temporary, they do not belong to anyone, they are unbounded, abundant and joyous. I also admit to having certain romantic notions about snow and ice: the Snow Queen, Lara and Zhivago breaking into the ice-covered summer house and Caspar David Friedrich's *Wreck of the 'Hope'*. These have a narrative element, they are about an image and its strong associative power. Much as I love the romantic possibilities, here the challenge was to use the material freely without this pictorial baggage.

My work is often constructed using geometric shapes, and I have always been interested in the purity of form and indiminishable nature of crystalline structures in materials that have no skin but are themselves the whole way through. So, I wanted to use the snow and ice in a way that allowed the natural processes, the weight, the pressure, the cracking, the uncontrolled elements to become part of a planned environment. We were not interested in creating voluptuous bodily forms; we agreed that the pavilion would have a sense of archaic structure, of first forms, rooted in basic shapes.

Eva Rothschild

Art Architecture: Engagement with the morphic process – a quiet, non-ironic critique of the formalist and anti-formalist paradigms – brings art and architecture together. We have no preconceptions about form. We do not see snow/ice as an unbounded neutral material. Rather, we animate the frozen and its own morphic language, seeing it as an active psychic process, at once mythic and ordinary.

Enjoyment – Space: Snow/ice is a material of collectiveness and joy. It liberates us from the anxieties of perfection and ownership. In psychoanalytic terms, snow/ice is the material of lack.

The Morphic Principles: Crystal and Archaic Theatre: Snow is a falling landscape in excess, nature's own animation, simultaneously natural and artificial. Eva worked with the concept of the crystal (mythical and structural). Anamorphosis focused on the archaic theatre, the spatial condition of play, collectiveness, static function and interaction, turning snow into a performance of itself. We inverted the theatre form twice: first, terraces became a sheltered alcove and an extrovert terraced hill and, second, screens of ice became a stage for light and shadow play as people walked through the piece.

Realization/Symbiosis: The morphic excess of the natural did not demand that the artwork transcended reality, nor that architecture was simply functional. When it was snowing, Crystal and Theatre spoke the same morphic language, and art and architecture exchanged roles: architecture sculpted the landscape whilst art built and materialized it.

Nikos Georgiadis, Anamorphosis

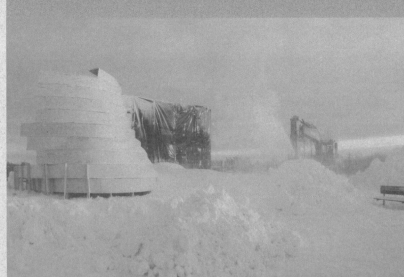

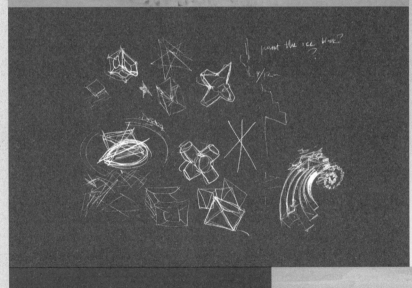

Background: Model,
Anamorphosis.

Top: Part-constructed
plywood mould.

Centre: Sketches, Eva
Rothschild.

Right: 3-D computer
rendering, Anamorphosis.

Far right: Smoothing down
a step of the amphitheatre.

Rachel Whiteread
Juhani Pallasmaa

Untitled (Inside)

The challenge was to work in collaboration with an architect in a completely unfamiliar material. The piece was made from snow and had a feeling of solidity; the viewer was able to walk into it. The form was based upon a simple stairwell space in East London that had been turned 90 degrees. The exterior of the piece was a pragmatic solution, simply reflecting the complex geometry of the interior. The new space felt familiar and domestic, and I hoped that it would disorient the viewer and make him or her think of other places.

Rachel Whiteread

Architecture is an art form of accommodation and mediation, whereas artistic statements tend to have a more autonomous and absolute character. So, we agreed at the very beginning of the project that the artist would suggest the motif. Rachel proposed the image of a stairwell turned sideways, which related to her recent sculptural work. Since I have also produced architectural objects based on images of stairways, in addition to designing actual staircases for my buildings, I immediately found the idea appropriate for our collaboration.

The volume of snow simply accommodated the interior space in a pragmatic manner without attempting to make an independent exterior statement. The exterior was the mute container of the articulated interior.

Juhani Pallasmaa

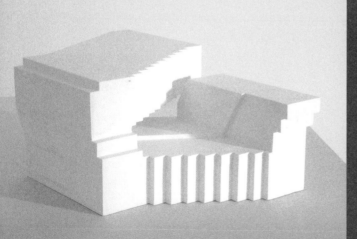

Far left: Model, Rachel
Whiteread.

Left: 3-D sketch of wire-
frame model, Juhani
Pallasmaa.

Below: 3-D drawing of the
structure, Rachel Whiteread.

Right: Construction of the
plywood moulds.

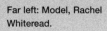

Cast Ice

Robert Barry
Hollmén-Reuter-Sandman

Top Changtrakul
LOT-EK

Ernesto Neto
Ocean North

Lawrence Weiner
Enrique Norten

Casting ice brings with it the problem of expansion, as a volume of water expands by approximately 10% when frozen. Different ways of casting ice were explored during the construction of 'The Snow Show': as solid sheets, as a hollow volume and as a large mass in layers. One thing is true to all processes: the thickness of the ice increases rapidly at first but the growth is slowed down as the ice gets thicker due to the outer ice acting as an insulator to the inside water. Weather plays a vital role in deciding whether the water in the moulds will freeze with the appropriate clarity or structural integrity or even whether it will freeze at all. The optimal freezing temperature for cast-ice constructions is -10°C.

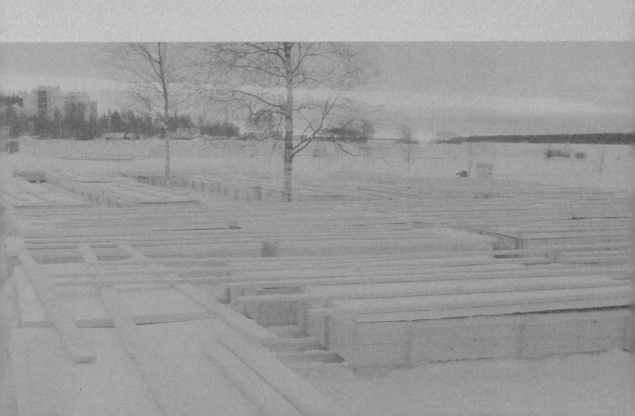

When casting the ice sheets for the Lawrence Weiner and Enrique Norten project, the freezing process had to be inversed. Water naturally freezes from the top downwards but here the water had to rise up instead of being captured under the ice, thus relieving the mould of a significant amount of pressure. For this reason, the 'ice walls' were frozen in moulds laid horizontally on the ground and only then were the moulds removed and the sheets delicately rotated vertically 90 degrees to their final position.

The two teams Robert Barry and Hollmén-Reuter-Sandman and Ernesto Neto and Ocean North employed a method of freezing inspired by the Finnish tradition of making ice lanterns. Cylindrical volumes were completely filled with

Previous spread: Top Changtrakul and LOT-EK, *Coloured Ice Walls*.

Left: Lawrence Weiner and Enrique Norten, *OBSCURED HORIZONS*.

Right: Robert Barry and Hollmén-Reuter-Sandman, *Lanterns of Ursa Minor*.

Bottom right: Top Changtrakul and LOT-EK, *Coloured Ice Walls*.

Far right: Lawrence Weiner and Enrique Norten, *OBSCURED HORIZONS*.

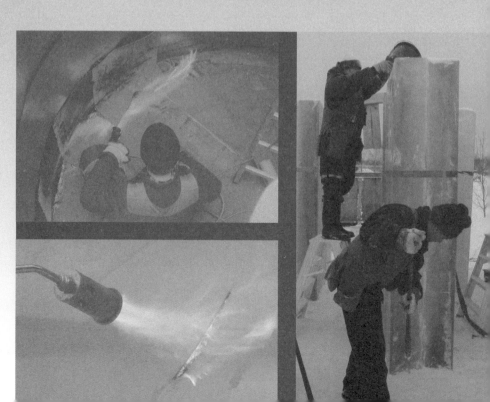

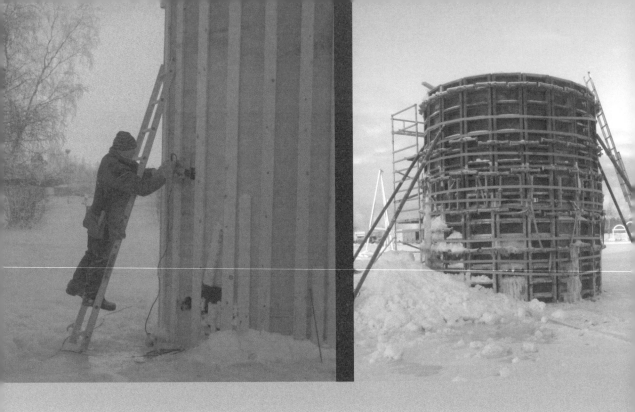

water, which was left to freeze for several weeks. Once frozen to the desired thickness on the top and sides, the water trapped in the centre of the ice was emptied out to create an interior space carved by nature.

With the massive ice walls of the Top Changtrakul and LOT-EK edifice, the technique was to freeze the ice in layers of 10cm to 15cm in height. This enabled the walls (20m x 3m) to freeze as solid structures rather than having to be assembled with ice blocks. The method also allowed the ice to release its pressure inwards incrementally to prevent it from expanding beyond the mould; had the moulds been filled at one pouring, the pressure when freezing would have caused them to explode.

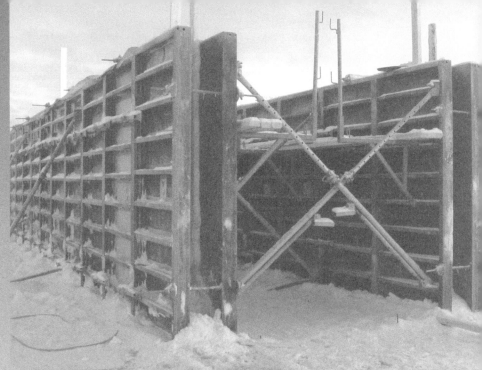

Far left: Robert Barry and Hollmén-Reuter-Sandman, *Lanterns of Ursa Minor*.

Left: Ernesto Neto and Ocean North, *Frozen Void*.

Top right: Top Changtrakul and LOT-EK, *Coloured Ice Walls*.

Right: Lawrence Weiner and Enrique Norten, *OBSCURED HORIZONS*.

Robert Barry
Hollmén-Reuter-Sandman

Lanterns of Ursa Minor

I sent some examples of my installations to Saija Hollmén and Helena Sandman and asked that they make space in their design for my piece. I was very pleased with the five identical ice lanterns the architects created and in which I inscribed my words. The lanterns' human scale, their confining curved interior walls and the fluid space between each of them created a dynamic space for my work. I like to think that my contribution to the project added an extra personal, ironic and even ambiguous dimension to the beautiful minimal experience.

Robert Barry

Five meditative spaces: each accommodated one person, each exuded the distinctive scent and taste, acoustics and intimacy of ice and snow. These ice lanterns were linked to the northern sky by the light of the five named stars in the constellation of Ursa Minor as projected on Rovaniemi at 8 pm on 10 February 2004. The miniature scale of the world of ice was brought close for discovery. Representing the five stars, the lanterns froze at a moment in time as we turned to travel through infinity.

Hollmén-Reuter-Sandman

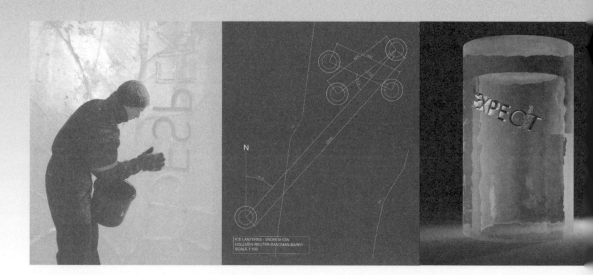

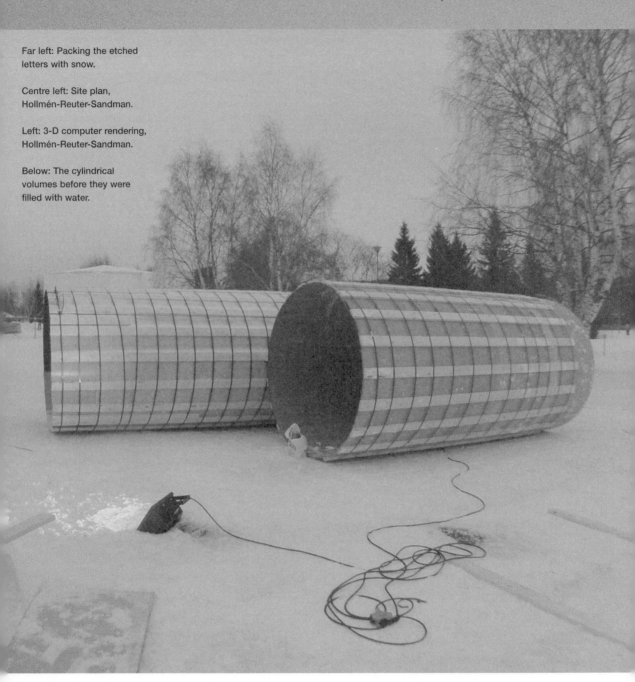

Far left: Packing the etched letters with snow.

Centre left: Site plan, Hollmén-Reuter-Sandman.

Left: 3-D computer rendering, Hollmén-Reuter-Sandman.

Below: The cylindrical volumes before they were filled with water.

Top Changtrakul
LOT-EK

Coloured Ice Walls

Top on working with LOT-EK:

In terms of materials, it was like shopping at the supermarket. First, they said they would be in charge of poultry and I would be in charge of vegetables and we would meet at the checkout fifteen minutes later. As agreed, we met at the checkout; LOT-EK took one look in my cart and asked, 'Why have you only picked cucumbers?' I replied, 'Because cucumbers are the only thing I like to eat.' Right there and then we had a problem. Our solution was to walk down every aisle together; we even visited the pet aisle although none of us has a pet.

In terms of ideas, it was like putting a jigsaw puzzle together without seeing the picture on the box. LOT-EK picked up a piece and saw a map, I picked up a piece and saw a country house. We stopped arguing and decided to finish the puzzle by using our differences, our instinct and our practicality. In the end, the puzzle was neither a country house nor a map. It was a cow.

Top on collaboration:

This project is not a 50/50 collaboration, and I am happy that it is not. If it had been, you would see an ugly tree house between the two red walls. We didn't want people coming into our space and saying Top did this, LOT-EK did that, or knowing where LOT-EK starts and Top ends.

Top Changtrakul

Ingredients: water, purple dye, 120-x-270cm concrete forms, rebars (concrete reinforcing bars), fluorescent tubes.

Pick a very cold location (i.e. Lapland).

Clear a piece of land measuring about 35 x 10m on which to build two parallel forms, each 25m long and 2.70m apart.

Wait until the temperature drops to about -27°C.

Mix the water with just enough dye to give it colour.

Make enough moulds to create the finished forms.

From the top of the mould, pour in the water-dye mix in layers. Each layer should be approximately 30cm high. Make sure each layer is completely frozen before pouring the next one.

When the top layer is reached, place the rebars across the space between the walls.

Once it is completely frozen, take down the moulds.

Do not remove the first pair of moulds at one end of the wall as they demonstrate the building process.

Once the moulds are removed, use some of them to create a wandering path through the space between the walls.

Stand the moulds between the walls, attaching them to the ground and the upper rebars.

Beginning at one end, place the moulds parallel to the walls and start turning them randomly until they are perpendicular to the walls.

Attach fluorescent tubes to some of the moulds. Turn the lights on. Enjoy the space within the walls and the purple glare without.

LOT-EK

Right: 3-D computer
rendering, LOT-EK.

Bottom left: Sketch, Top
Changtrakul.

Bottom right: Once the ice
walls were completely frozen
the moulds were lifted away
by crane.

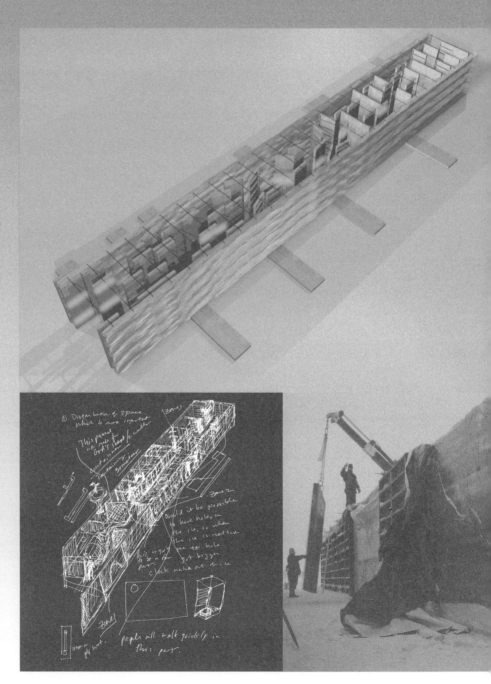

Ernesto Neto
Ocean North

Frozen Void

How good it is to let things evolve – just see
what happens!

We made a small room from a big cup of
water. An ice bubble that we could get into and
discover what it would be like inside frozen water.
An experiment on an old-new way of making an
ice castle.

Ernesto Neto and Ocean North

**Right: Finished model,
Ocean North.**

**Far right: The mould
withstanding the pressure
of the freezing water.**

**Below: The process of
making the model, Ernesto
Neto and Ocean North.**

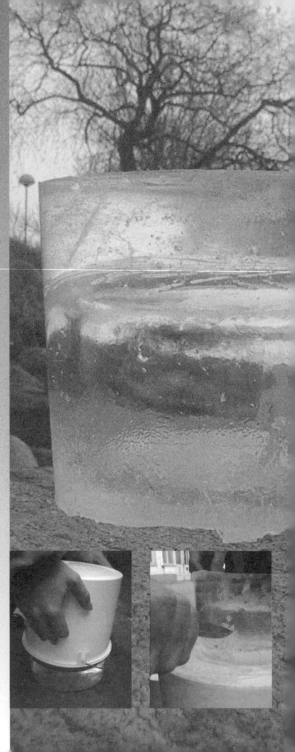

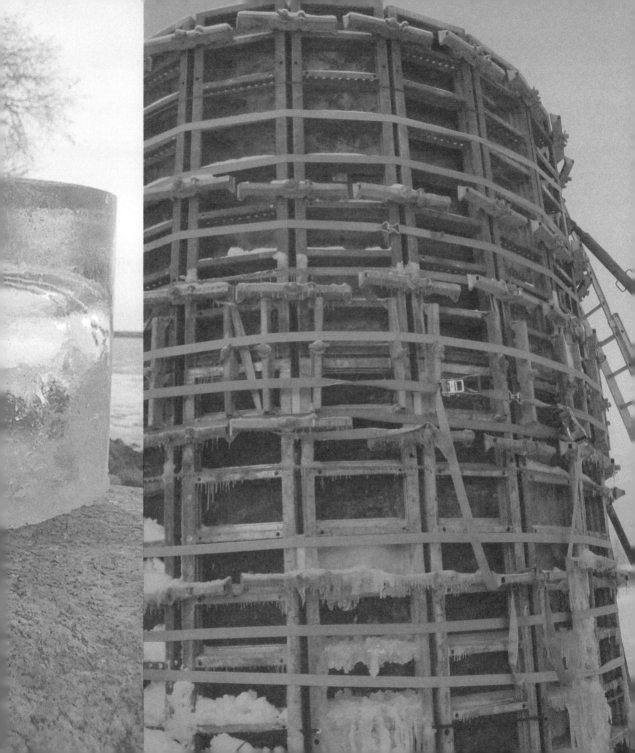

Lawrence Weiner
Enrique Norten

OBSCURED HORIZONS

Defined by a series of ice walls, the design emphasized the opportunity for multiple experiences and readings. The piece was a non-processional space that explored an architectural experience through different media and direct sensations: temperature, colour, light, sound (wind) and so on.

Tension and compression were created among the frozen elements. Snow and ice elegantly shaped the walls and hallways in a non-hierarchical manner that produced unexpected openings. Light and colour created different atmospheres in the spaces, which essentially remained silent, waiting to be explored.

The materialization of the design was unlimited, an assortment of enclosures and apertures that suggested a discontinuous composition with an open-ended result. Colour and the transparency of the walls conveyed multidimensional scenes within the configured outlook.

The project described content and absence beyond time and space. It was a sequence of gestures that gave materiality to the illusion and represented an endless framework, as Lawrence Weiner calls it, an 'obscured horizon'.

Enrique Norten

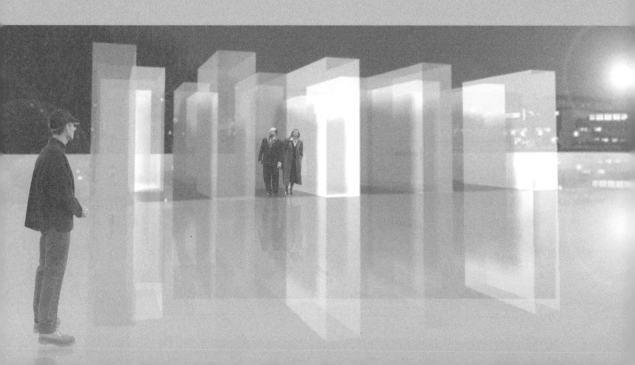

AN ATTEMPT TO BUILD WITH AN ARCHITECT A MISE EN
SCENE OF WHATSOEVER DURATION THAT AT EACH STAGE
OF ITS TENURE RETAINS THE MATERIAL REALITY (MEANING)
OF THE RATIONALE FOR ITS PLACE IN THE SUN IN FULL
VIEW OF ALL TO SEE

Lawrence Weiner

Far left: 3-D computer
rendering, Enrique Norten.

Below left: Moving the ice
walls into their upright
positions.

Above: Axonometric,
Enrique Norten.

Below: Conceptual designs,
Lawrence Weiner.

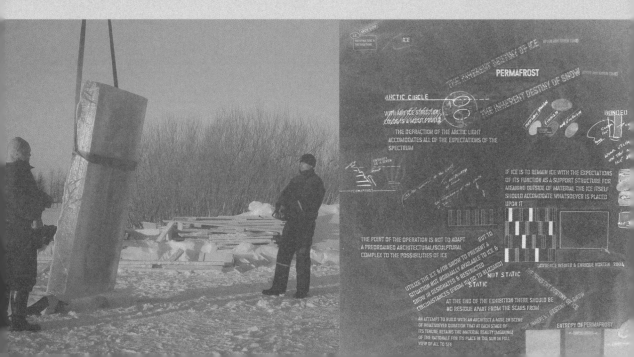

Harvested Ice

Cai Guo-Qiang
Zaha Hadid

Jene Highstein
Steven Holl

Tatsuo Miyajima
Tadao Ando

Yoko Ono
Arata Isozaki

Do-Ho Suh
Morphosis

The ice blocks used in these constructions were cut from the surface of a frozen lake. Lake ice freezes in two layers: the lower layer, suitable for construction, is bright and consistent while the top layer, after enduring the elements during the freezing, has an opaque and clouded appearance and can be cut away during the harvesting process. Harvested ice is either turquoise or bluish depending on the minerals contained in the water. Weather determines the amount of time the water has to freeze, which in turn, defines the thickness of the layer used for ice construction.

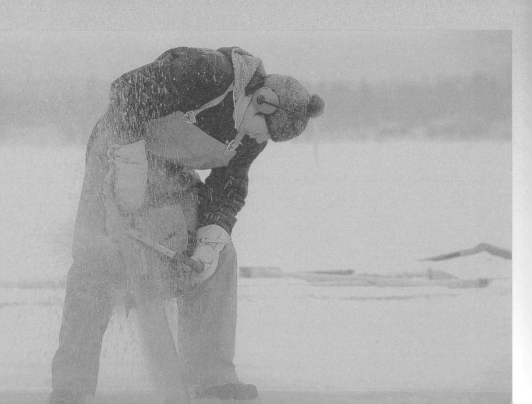

The blocks were cut out of the lake surface using a chain saw (with no grease on it) and were lifted onto trucks by standard logging cranes to be transported to the site. As moving a block can affect its structural integrity, the volume of a single ice block was kept to less than 1 cubic metre; an average block measured 1 metre in length by 0.6 metres in height by 0.6 metres in width.

In Yoko Ono and Arata Isozaki's construction and in Jene Highstein and Steven Holl's colossal design, the blocks were positioned and joined to each other following a similar method to standard masonry. Adjoining surfaces were finished to fit tightly together using table saws, chain saws and hand chisels. When the temperature fell to -20°C or below the ice became almost too brittle to work

Previous spread: Cai Guo-Qiang and Zaha Hadid, *Caress Zaha with Vodka/Icefire*.

Left: Jene Highstein and Steven Holl, *Oblong Voidspace*.

Right: Yoko Ono and Arata Isozaki, *Penal Colony*.

Far right: Cai Guo-Qiang and Zaha Hadid, *Caress Zaha with Vodka/Icefire*.

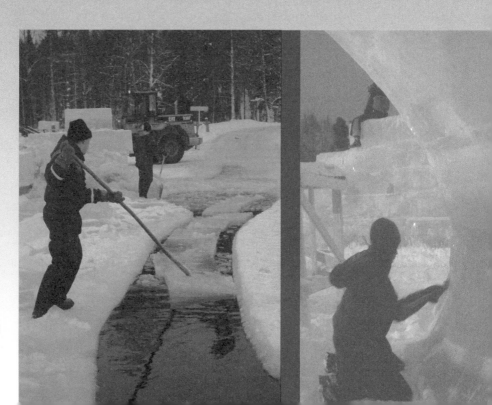

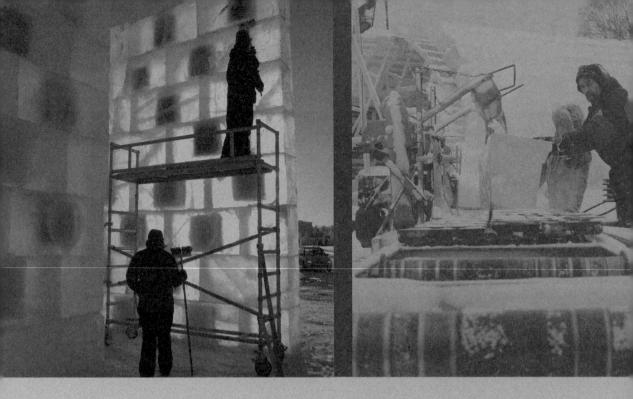

with; at these temperatures a wrong move with a tool or an incorrect placement would have severely damaged the block or surrounding blocks. Once a block had been set in place, water was poured into the gaps fusing the ice together. Ice constructions were finished using a setaline torch to slightly graze the façade of the construction, smoothing out rough edges and burning away any surface frost or debris to leave a sparkling, translucent quality.

Embedding polycarbonate bubbles filled with a coloured antifreeze solution posed a challenge in the construction of the Do-Ho Suh and Morphosis project. The bubbles had to be filled with a saline solution to prevent the water contained within them from freezing and expanding, which would have burst the bubble. The liquid-filled bubbles were set into holes cut out of the lake and then water was

poured in to secure the bubble and fill in the remainder of the cavity.

To successfully defy what was considered impossible, an intricate and extremely precise framework of wood and steel was constructed to create a vaulted tunnel completely out of ice blocks. When Tatsuo Miyajima and Tadao Ando conceived their design, nothing like it had ever been attempted and nobody knew if it would stand on its own after the framework had been removed. With this in mind, a complex system was developed to cut the ice blocks to the calculated angles to prevent slippage, which would have sent the structure crashing to the ground.

Cai Guo-Qiang and Zaha Hadid's piece also presented a challenge in structure and balance when Hadid proposed a massive cantilever of ice.

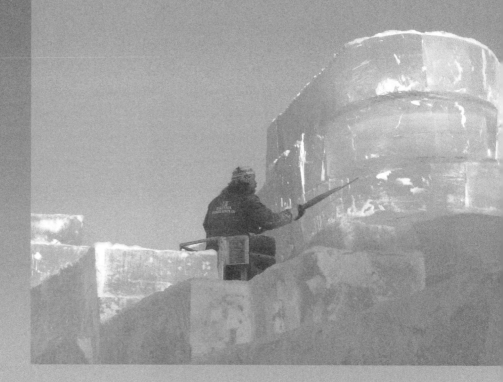

Far left: Do-Ho Suh and
Morphosis, *Fluid Fossils*.

Left: Tatsuo Miyajima and
Tadao Ando, *Iced Time
Tunnel*.

Right: Cai Guo-Qiang and
Zaha Hadid, *Caress Zaha
with Vodka/Icefire*.

However, it was not until Cai Guo-Qiang intervened
with the idea of pouring flaming vodka over the
side of the cantilever to produce a waterfall of
flames that new methods had to be developed.
Several important questions had to be addressed:
how can the vodka stay fluid enough to maintain its
flame while not dissolving too quickly into the ice;
how can we ensure that the cantilever will not lose
its stability under the burning hot conditions? The
answer was an ethanol-based gel and vodka
mixture that allowed the fire to burn under windy
conditions while keeping a portion of the heat away
from the ice surface.

Cai Guo-Qiang
Zaha Hadid

Caress Zaha with Vodka/Icefire

soft/hard
rigid/fluid
cold/warm
blue/pink
line/volume

I poured vodka over Zaha Hadid's fluid ice and snow structure and set alight the liquid to produce a cool, blue flame that wrapped the installation in warmth. The blue flame, with licks of pink, roamed along the curves and valleys of the landscape, spreading, dripping, meandering and cascading into waterfalls and streams.

The fire set the ice and snow environment in a heightened pure transparent light. The warmth softened the angles, corners and rigidity of the icy forms whilst at the same time carving into the surface. The fire highlighted the space's contours: the melted ice water mixed with alcohol flowed freely on and around the structure, rendering it in a state of constant movement and change.

Cai Guo-Qiang

Landscapes of ice and snow are exciting natural entities, striking for their fluid shapes and coherent formations. We created a man-made landscape that intensified the experience of the space while provoking joy and a sense of exploration in its visitors.

Ice was treated as a medium to be sculpted and carved. Vaulting, floating spaces and canyons formed an area that enveloped visitors in a glowing ever-changing glacier. Walls curved into ceiling and floating structures that challenged gravity, giving visitors the sensation of being in a frozen but fluid environment. 'Veins' of light of different intensities and qualities informed the space and were woven into the landscape.

The structure reflected a frozen moment of a fluid momentum and the return to nature, or to the fluid condition of water as it melts. The perception of the installation as a fluid space and the captive light in that condition was intensified by its temporary nature.

The constant state of change during the melting process revealed unknown and unexpected realities, volumes and spaces.

Zaha Hadid

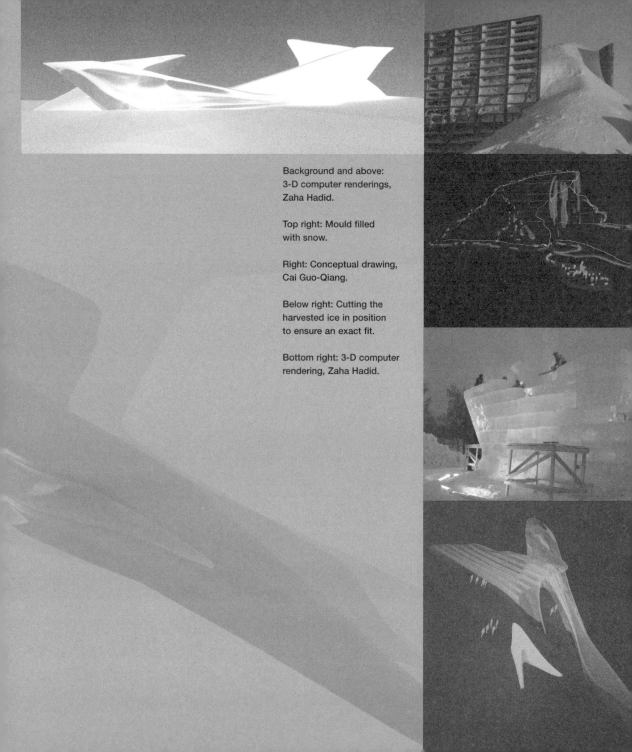

Background and above:
3-D computer renderings,
Zaha Hadid.

Top right: Mould filled
with snow.

Right: Conceptual drawing,
Cai Guo-Qiang.

Below right: Cutting the
harvested ice in position
to ensure an exact fit.

Bottom right: 3-D computer
rendering, Zaha Hadid.

Jene Highstein
Steven Holl

Oblong Voidspace

It may sound like a theoretical construction, but *Oblong Voidspace* was in fact a highly tactile and sense-oriented structure. Almost cubic on the outside, it was accessed by an interior stairway, which led to a vessel-like space open to the sky. In a sense it was about the absence of sculpture: the outside being more architectural and the inside more experiential. Like a ceremonial space, the interior focused attention on the convergence of body and mind.

Jene Highstein

Conceived as an experience in space and light, the interior of the 9-metre-tall cube of ice was modelled on the absence of a huge monolithic shape, which is characteristic of Jene Highstein's sculpture. We calculated that the melting ice would create a hole in *Oblong Voidspace*, which was sited on the river's edge outside the city of Rovaniemi. This allowed an uninterrupted view to the city and first appeared on 21 March 2004.

Steven Holl

Above: Sketch, Steven Holl.

Right: Gently lifting the blocks into position.

Far right: Cross section and elevation, Steven Holl.

Far right, top: Sketch of ice doorway, Jene Highstein.

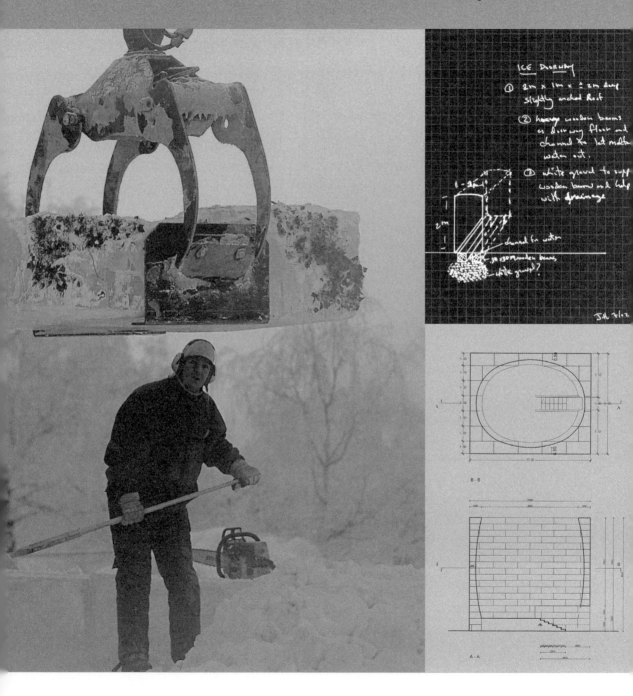

Tatsuo Miyajima
Tadao Ando

Iced Time Tunnel

Each counter gadget represented the brightness
of human life. When the displayed number was
counting from 1 to 9, it indicated 'life'; when the
number did not appear, the darkness signified
'death'. This constant cycle of life and death
originates in Buddhist philosophy. By enclosing
seventy counter gadgets in the ice tunnel, designed
by Tadao Ando, I regarded this collaborative work
as the 'time tunnel of life'. I expected visitors to feel
the continuous cycle of life from time immemorial
and to think about the dignity of life.

Tatsuo Miyajima

Using ice, an ephemeral and formless material,
I created a minimal and purified form, with the
motif of a continuous curved line. What emerged
in the geometrical space of ice was a 'sequence'
of light and air. The abstract concept, the sequence,
also responded to Tatsuo Miyajima's artwork, the
themes of which were 'time and space', from
past to present and from present to future.The
collaboration, *Iced Time Tunnel*, was completed
by combining the sequence of my architecture
with the time and space of Miyajima's work.

Tadao Ando

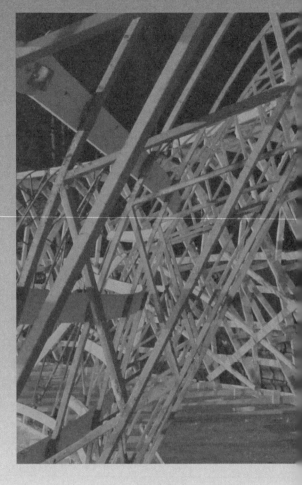

**Above: The highly complex
wood-and-steel framework
for the tunnel.**

**Right: Sketch of the tunnel's
opening, Tadao Ando.**

**Far right: Architectural
drawing, Tadao Ando.**

**Far right, top: Dismantling
the framework after the ice
blocks were in place.**

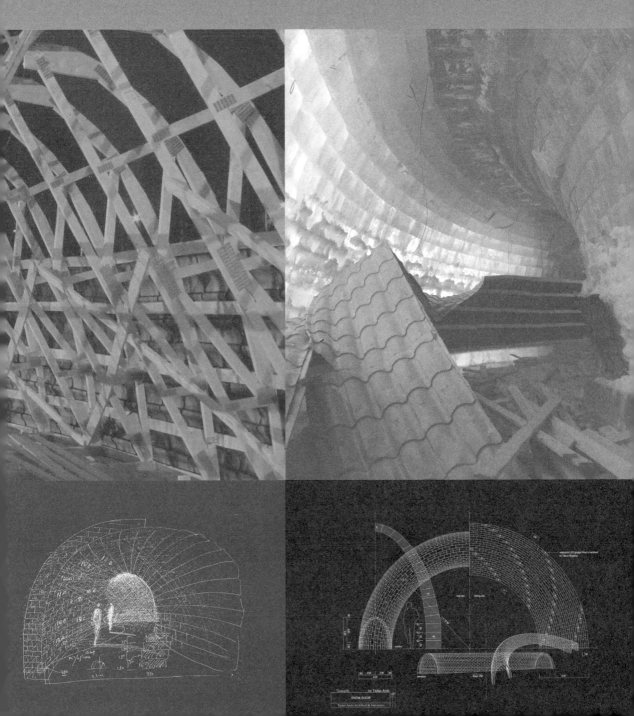

Yoko Ono
Arata Isozaki

Penal Colony

Penal Colony

spring passes

and one remembers one's innocence

summer passes

and one remembers one's exuberance

autumn passes

and one remembers one's reverence

winter passes

and one remembers one's perseverance

there is a season that never passes
and that is the season of glass

© Yoko Ono 1981

Hell in Paradise

This is Hell in Paradise
We're all asleep or paralyzed
Why are we scared to verbalize
Our multicolor dreams

When will we come to realize
We're all stoned or pacified
While the boogie men organize
Their multilevel schemes

Underqualified for love
Overqualified for life
Sticking our heads in slime
Thinking we're in our prime

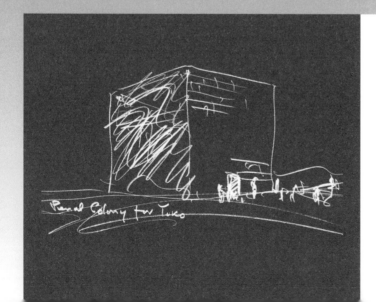

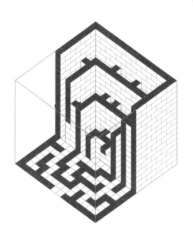

Mesmerized by mythology
Hypnotized by ideology
Antagonized by reality
Vandalized by insanity
Desensitized by fraternity
Sanitized by policy
Jeopardized by lunacy
Penalized by apathy
And living in the world of fantasy
Dancing on hot coal
Waiting for the last call
It's Adam's ball
Eve's call

Wake up, shake up, check out, work out, speak
out, reach out, it's time to, time to, time to, to, to,
to, to...........

This is Hell in Paradise
None of us wish to recognize
But do we want them to materialize
An endangered species.....................................

Exorcize institution
Exercise intuition
Mobilize transition
With inspiration for life

© Yoko Ono 1985

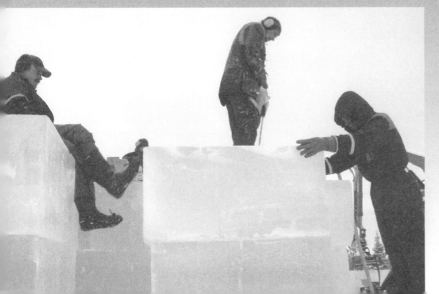

Left: Blocks are very
carefully placed before
being finished to tightly
fit together.

Centre left: Isometric
section, Arata Isozaki.

Far left: Sketch, Arata
Isozaki.

Do-Ho Suh
Morphosis

Fluid Fossils

'But if the [viewer] can be convinced that there is, under the superficial imagery of water, a series of progressively deeper and more tenacious images, he will soon develop a feeling for this penetration in his own contemplations; beneath the imagination of forms, he will soon sense the opening up of an imagination of substances. He will recognize in water, in its substance, a type of intimacy that is very different from those suggested by the "depths" of fire or rock. He will have to recognize that the material imagination of water is a special type of imagination. Strengthened in this knowledge of depth of a material element, the [viewer] will understand at last that water is also a type of destiny that is no longer simply the vain destiny of fleeting images and a never-ending dream but an essential destiny that endlessly changes the substance of the being.'

Gaston Bachelard, *Water and Dreams: An Essay on the Imagination of Matter*

Fluid fossils…embedded objects…constructed archaeology.…This project explored the transformation of matter in time. **Water**: qualities of its materiality – sometimes subtle, sometimes not – persistently ephemeral, ever-changing…fluid and frozen…subtleties of its translucence and colour emerge…more visible now…yet as fleeting as moments passing.

Do-Ho Suh and Morphosis

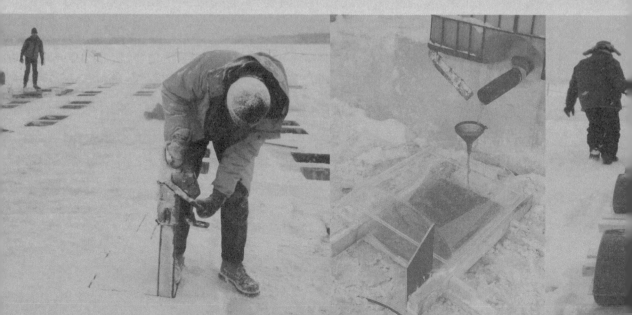

Far left: Cutting blocks from the surface of a frozen lake to insert polycarbonate bubbles.

Centre left: The bubbles were filled with coloured antifreeze and a saline solution.

Below left: The liquid-filled bubbles were transported to the site by sleigh.

Below: Placing the bubbles in their allocated holes.

Below right: Putting the finishing touches to the piece.

Right: Elevation drawings, Morphosis.

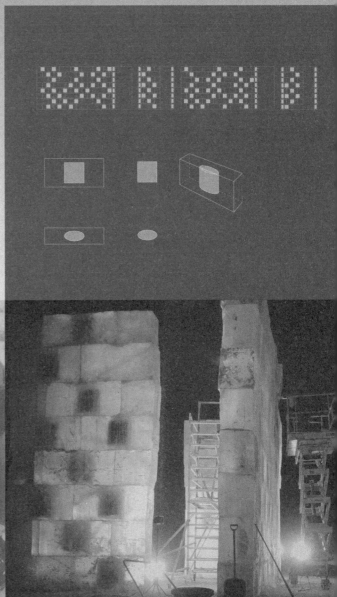

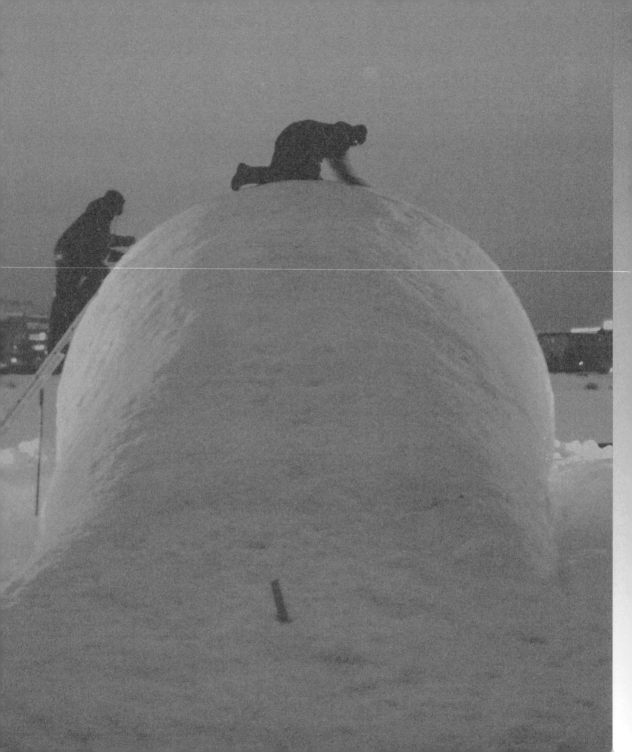

Experimental Processes

Lothar Hempel
Studio Granda

Anish Kapoor
Future Systems

John Roloff
Diller + Scofidio

Kiki Smith
Lebbeus Woods

The entire realization of 'The Snow Show' was experimental, challenging the traditional methods of snow and ice construction. But, the projects in this section were the most innovative in their execution and the most unpredictable in their outcome.

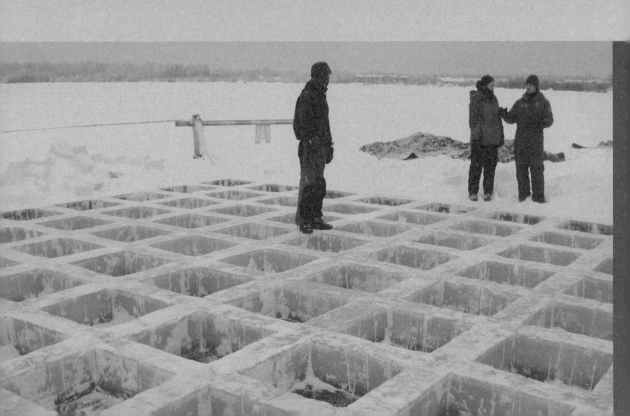

The essence of the Lothar Hempel and Studio Granda work was the creation of ice from its very beginnings as gas and liquid. A system of underground pipes that led to a tank containing heated water was established to facilitate the design's goals. One set of pipes pumped steaming hot water into the pool, while a second sent siphoned water from the pool back into the tank to be reheated. The desired effect was not evident until the design's completion. Fortunately, the water remained hot enough in the sub-zero environment to create steam and to form ice crystals on the tree branches in the surrounding landscape.

Making the biomorphic shape for the project by Anish Kapoor and Future Systems was an

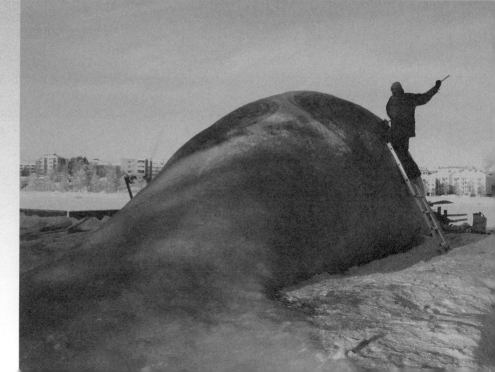

Previous spread: Anish Kapoor and Future Systems, *Red Solid*.

Left: John Roloff and Diller + Scofidio, *Pure Mix*.

Right: Anish Kapoor and Future Systems, *Red Solid*.

experiment in defying gravity. Water at the base of the structure had to freeze on an oblique surface and, once frozen, had to support the entire weight of the piece. First, a mould was created using a steel framework covered with plywood sheets. Snow was blown onto the mould to create a base layer, then smoothed and shaped using hand tools. When the shape was finished, pigment-dyed water was sprayed onto the form several times to create layers of coloured ice that eventually amounted to 10cm in thickness, at which point the mould had to be removed from underneath. A tunnel was dug into the snow that allowed the workers to remove the steel and wooden structure without having to cut into the form. The slightest of disturbances while removing the mould would have brought the icy shell crashing down on the workers. Once the

mould was removed the ice stood unaided and supported the weight of the project.

By building a piece into a frozen sea, John Roloff and Diller + Scofidio created an environment in which the longevity and stability of the project was uncertain. Eighty-one reservoirs were cut out of the sea's frozen surface and filled with bottled waters, which froze within the confining 'mould' of sea ice. The main difference between this and casting ice using a wooden mould is that the sea is constantly moving below the ice layer, which can cause the ice to fracture and shift. According to the design, LEDs were placed at the bottom of the reservoirs to create a glowing effect to backlight the etched logos and illuminate the ice field. In the end, the pressure of the ice was too strong for the lights and they started to

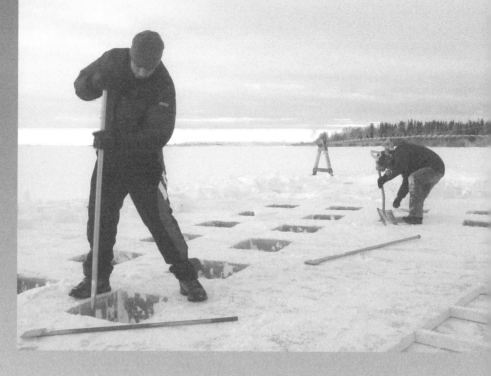

change colour before fading into the darkness
of the sea.

Transparency was a key concern for the team
of Kiki Smith and Lebbeus Woods. Tests and rough
calculations were made to ensure that Kiki Smith's
figures and Lebbeus Woods's light paths would still
be seen through the ice during day and night
viewing. Inset into the earth, their ice pool rested
flush within the landscape while using the natural
topography. The ice was frozen in several layers to
ensure the required amount of clarity and to more
accurately control the level of the surface. Each
layer of ice was left to freeze completely solid
before the figures were set in place and a cover
had to be used to make sure that impurities and
frost did not interfere with the clarity between layers
during the freezing process.

Lothar Hempel
Studio Granda

Katzenauge/Catseye

Water
Hot
Impure
Steel
Pole
Lights
by
Peek
Cycle
incomplete

Lothar Hempel and Studio Granda

Below left: Sketch, Lothar
Hempel.

Below: Section and plan,
Studio Granda.

Below right: Digging out the
area for the hot-water pool.

Right: Steam rising as a
result of the system of
underground pipes.

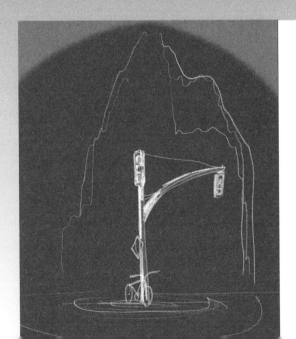

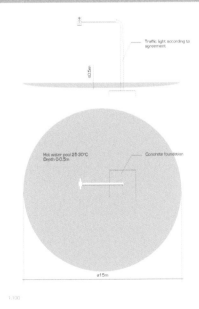

Traffic light according to agreement.

≤0.5m

Hot water pool 25-30°C
Depth 0-0.5m

Concrete foundation

ø15m

1:100

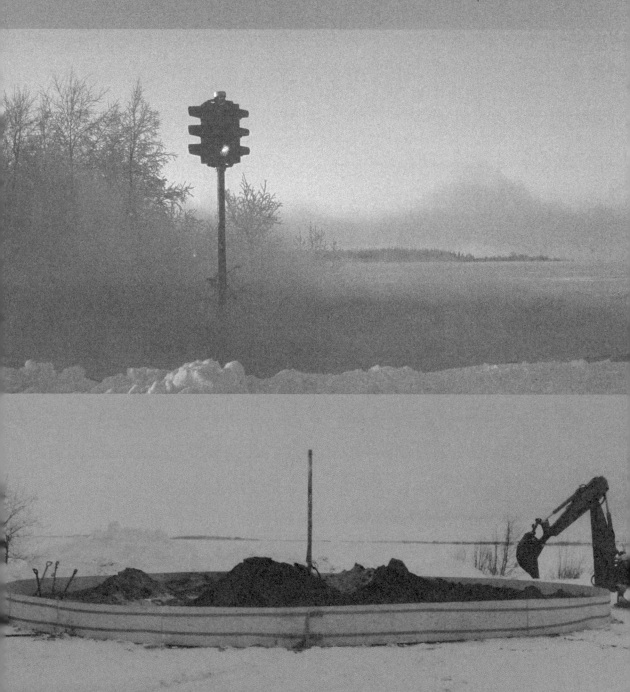

Anish Kapoor
Future Systems

Red Solid

Ice was the material for *Red Solid*.
The liquid/solid properties of ice led to the form.
Space was contained but there was no entry.
The pool was a partial residue of the solid.
200 holes made skin and solid into one.

Anish Kapoor and Future Systems

A.k. 25.03

A.k.
2.5. 03

Top left: 3-D computer
rendering, Future Systems.

Above: Sketches of the
piece in the landscape,
Anish Kapoor.

Left: Spraying coloured
water onto the form.

Right: Smoothing off the
surface after spraying.

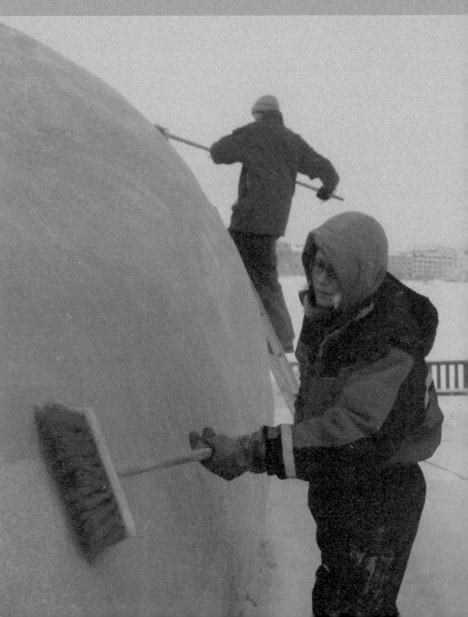

John Roloff
Diller + Scofidio

Pure Mix

Pure Mix was an 81-square-metre mosaic of designer waters embedded in the frozen sea of the Gulf of Bothnia. The field of frozen water was composed of 81 inscribed ice blocks, each one constructed from 170 litres of commercially available branded water from around the globe. This geopolitical and cultural water matrix was cyclically transformed: natural water was 'purified' by commerce, organized by ethos and sublimated by nature.

The work synthesized Diller + Scofidio's provocative examinations into cultural and architectural issues and Roloff's engagement with site, nature and systems. It related culture, architecture and nature through the media of water and climate and was located at the edge of the city of Kemi and the northern part of the Gulf of Bothnia, where the frozen land meets the frozen sea. Twenty metres out from the shoreline, the rectilinear grid of designer waters was frozen into the solid ice of the sea and was aligned visually with two immense effluent stacks from the paper mill on the opposite shore in commercial sympathy and as an ecological commentary.

Each frozen water had its logo embedded on its surface and was illuminated from within the depth of the ice by LED lights that were installed at the bottom of each reservoir, confounding the merging of culture and nature.

Waters were strategically positioned within the grid, causing cultural and political tension between neighbouring waters. The physical life of the collection was tethered to the frigid climate of the Lapland winter while its incorporeal life existed in the stress created by the imminent threat of mixing with neighbours and the dispersal into the sea come spring.

The organization of the grid linked vice with virtue: commercially available boutique waters enhanced with additives like nicotine ('Nicowater') or caffeine ('Buzzwater') resided next to sacred waters ('Lourdes' from France, 'Jordan River' from Israel, and 'Holy Water' from St. Patrick's Church in New York City) that are sold with blessings or are purported to have healing properties. There were also waters with ambiguous ties to the sacred and the profane like 'Oxywater', 'Smartwater', or fat-burning 'Evamor' water.

North Korea's 'Sindok', Iran's 'Damavand' and Iraq's 'Hayat' aligned with premium brands from the US, UK and Spain. There was 'Abe-e-Kabul' from Afghanistan, 'Ein Gedi' from Israel and 'Nada' from Palestine as well as such top-shelf brands as 'Voss Artesian' and 'Borsec'. 'Ciego Montero', Cuba's only bottled water, aligned with 'Aquafina', America's best-selling water comprising 90% Detroit tap water, and 'Houston Superior', the self-proclaimed universally superior municipal water from Texas.

Through a process of deposition, context and dispersal, designer waters linked culture to nature and the project site to the external world.

John Roloff and Diller + Scofidio

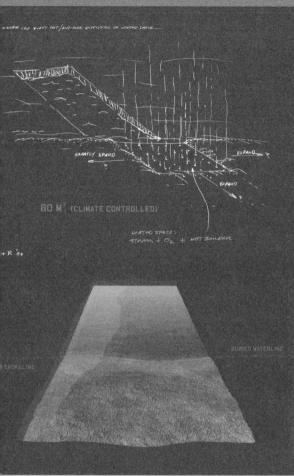

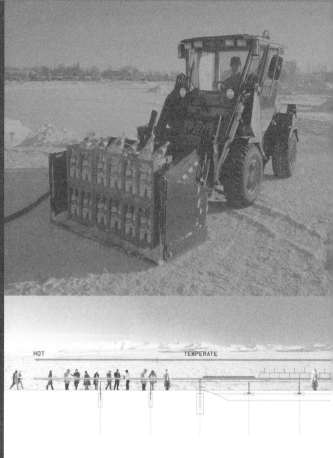

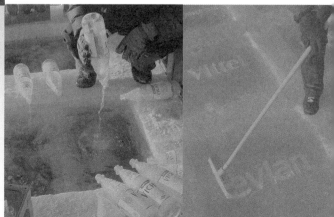

Above: Conceptual sketch and illustration, Diller + Scofidio.

Top right: Tractors transported the water to the site.

Centre right: Computer rendering, Diller + Scofidio.

Right: Filling one of the mosaic squares.

Far right: Brushing down the frozen surface.

Kiki Smith
Lebbeus Woods

Skypool

Whether through proximity, osmosis, telepathy or serendipity, Lebbeus and I independently desired to manifest a similar situation in Lapland. Given the enormous range of possibilities, it still somehow occurred to both of us to make

something that lies in the land,

a mirror to the sky,

an illumination,

a murky pond,

an observatory,

a magic well,

a hole, a sunken treasure,

a starscape,

a light drawing,

quiet, dangerous,

an open cavity that makes itself apparent for a time then erases itself back into the land.

Kiki Smith

Pools of ice, geometric in the ground, with figures – human and not – frozen and suspended in them.

You walk, skate on the ice pools.

You look down into the ice.

You see, or almost see, the figures.

Snow blows across the ice pools, covering edges and the figures, too.

By day, the figures are shadows in the dark ice.

By night, the ice glows and the figures are illuminated, though darkly.

They have been there forever.

Waiting.

Now the ice is melting.

The ice pools are melting, and the figures are revealed. Little by little, they emerge from the melting ice.

In the end, there are only the empty pools, empty of ice and of water.

The figures rest on the bottom of the empty pools.

Then the pools are filled with earth.

Lebbeus Woods

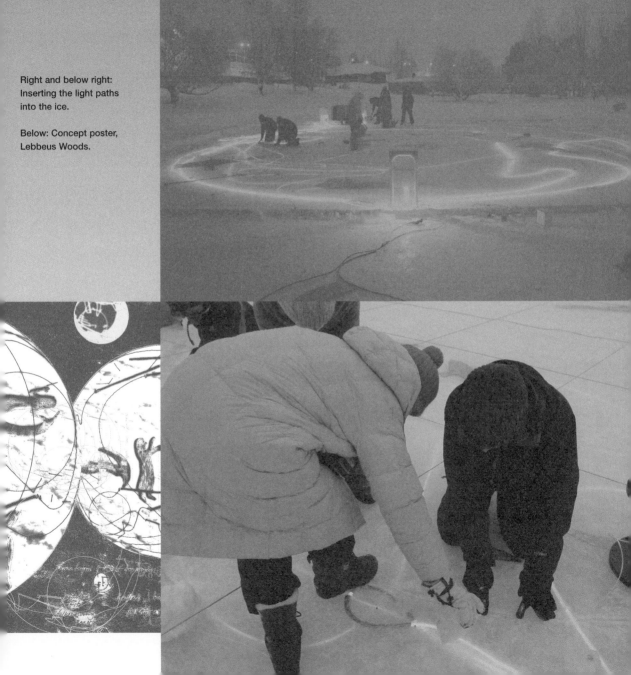

Right and below right:
Inserting the light paths
into the ice.

Below: Concept poster,
Lebbeus Woods.

Project Credits

Meeting Slides
Carsten Höller
Tod Williams Billie Tsien & Associates

Absolute Zero: A Light House of Temporality
Osmo Rauhala
Asymptote: Hani Rashid and Lise Anne Couture

**The Morphic Excess of the Natural/
Landscape in Excess**
Eva Rothschild
Anamorphosis Architects

Untitled (Inside)
Rachel Whiteread
Juhani Pallasmaa
Assistants: Ze'ev Lipan, Joren Bass

Lanterns of Ursa Minor
Robert Barry
Hollmén-Reuter-Sandman Architects

Coloured Ice Walls
Top Changtrakul
LOT-EK

Frozen Void
Ernesto Neto
Ocean North: Tuuli & Kivi Sotamaa

OBSCURED HORIZONS
Lawrence Weiner
Enrique Norten
Artist assistant: Bethany Izard

**Caress Zaha with Vodka (Cai Guo-Qiang's
intervention title)/Icefire**
Cai Guo-Qiang
Zaha Hadid
Cai studio project manager: Jennifer Wen Ma
Project director: Patrik Schumacher
Project architect: Rocio Paz
Project team: Yael Brosilovski, Helmut Kinzler,
 Judith Reitz
Lighting: Zumtobel Staff

Oblong Voidspace
Jene Highstein
Steven Holl Architects

Iced Time Tunnel
Tatsuo Miyajima
Tadao Ando Architect & Associates
Artist assistant: Yoshiko Isshiki Office
Project architects: Tadao Ando, Antoine Müller Moriya
Construction coordinators: John Jourden,
 Seppo Mäkinen

Penal Colony
Yoko Ono
Arata Isozaki and Associates

Fluid Fossils
Do-Ho Suh
Morphosis

Katzenauge/Catseye
Lothar Hempel
Studio Granda

Photography Credits

Red Solid
Anish Kapoor
Future Systems

Pure Mix
John Roloff
Diller Scofidio + Renfro
Project leader: Matthew Johnson
Project assistant: Gaspar Libedinsky

Skypool
Kiki Smith
Lebbeus Woods
Lighting design: Lebbeus Woods with Linnaea Tillett
and Seth Tillett

Albert Comper/Galahad: 2 (bottom right), 27, 29, 31, 32, 46, 47 (top left), 48 (right), 56 (bottom row), 57–59, 69, 71 (top), 72, 81 (bottom left), 96, 101, 113 (right), 115 (bottom row), 132, 142–43
Lynn Davis: 37, 45, 93
Jeffrey Debany: 2 (top right and bottom left), 13–17, 33–35, 38–43, 47 (middle row and bottom), 48 (left), 49, 53–55, 56 (top left and right), 70, 73–77, 81 (top left), 82–83, 94–95, 98–99, 109–12, 114, 115 (top row), 117–21, 125–29, 134–40, 146–47, 149, 150 (right), 151, 152, 153, 155 (top left), 157 (top and bottom right), 159 (right), 160, 162, 163, 164 (right), 165, 166 (left), 167, 169 (bottom right), 171 (right), 173 (bottom left), 177 (left), 178 (right), 181 (top right and second from bottom), 184, 185 (top right), 187, 188–89, 190, 193, 194, 195, 197 (bottom and top), 199 (right), 203 (bottom)
Matthew Johnson: 201 (bottom right)
Ville Kostamoinen: 30, 62–63, 97, 102–07, 141 (right), 144
Gaspar Libedinsky: 192
Sam Rosenthal: 201 (top right and bottom left)
Toni Cenicola: 1
Camille Moussette: 47 (top right), 50–51, 71 (bottom), 123, 131, 133, 164 (left), 175, 177 (right), 178 (left), 179, 198, 203 (top), endpapers
Ericka Hedgecock: 16, 18–19, 74, 150 (left), 163 (bottom left), 169 (bottom right), 189 (right)
Mane Stenros: 2 (top left), 21–27, 85–88, 90, 148, 155 (top left), 176, 183 (left)
Hélène Binet: 78–79, 81 (top and bottom right)
Kivi Sotamaa: 61, 62 (top right), 64–67, 170

Acknowledgments

With collaboration as the curatorial premise, it is easy to see that the success of 'The Snow Show' and this wonderful book relied on the belief and efforts of many people. I would first like to thank the talented participants (and their assistants and offices) who gave so much to the project. Their friendship, faith and brilliant ideas allowed me to traverse the intrinsic difficulties of the project with energy to realize what most had suggested was impossible. The visionary approach and committed efforts by each of the forty-seven artists and architects were a testimony to the desire of collaboration and challenge. Now that the exhibition remains only as a book containing proposals, statements and photographs, the true dialogue and works in progress are found in the exchange of ideas, vision and friendships that have only just begun.

The realization of the exhibition would never have occurred had it not been for a faithful staff who gave up their personal lives for two-and-a-half years. Our midnight meetings and weeks of no sleep during the final construction phase were heroic. The 24/7 work week became normal for all of us. One of the most important by-products of working on this project is the lasting friends I have made. However, Jeffrey Debany, John Jourden, Noémie Lafaurie, Layman Lee, Salla Virman and Thomas Watkiss are more than friends, they have become my family. They all illustrated a passion for and an allegiance to the show and to each individual building project. Their fight for the exhibition has been an inspiration to me, and I hope the projects contained in this book are proof of our vigilant efforts.

I would be remiss to not recognize Ian Arnold, Meira Chefitz, Albert Comper, Lynn Davis, Riitta Haarakoski, Ericka Hedgecock, Jon Hendricks, Joseph Mills, Camille Moussette, Eros Piovesan, Jessica Sledge, Mane Stenros, Gianni Talamini, Ming Thompson and Yuna Yagi for their continued support. Their 'volunteerism' fuelled the project in every way, ranging from research to the actual snow and ice building in temperatures of -45°C.

Additionally, I need to thank Hiroko Abe, Michael Benevento, Marja Bloem, Liesbeth Bollen, Orin Buck, Paul Burkhardt, Malcolm Daniel, Devon Dikeou, Jonathan Fung, Richard Humann, Daniel Korb, Ville Kostamoinen, Erin Long, William Penner, Guy Rabut, Joshua Selman, Jasper Sharp, Kimberly Thompson, Henry Urbach and Seth Weine for their contributions.

The generous support and introductions to their many contacts and friends by Marie Brandolini d'Adda, Piero Addis, Emily Harvey, Howard Moore, Michael Hue Williams, Davidson Gigliotti, Guillaume Malle, Marlene Nathan Meyerson, Hans D'Orville and Samara Powell added to the success of the first 'Snow Show'. With continued efforts by all, I look forward to new adventures as the show develops.

I would like to express my sincere appreciation of the 121 volunteers who worked tirelessly into the wee hours of the morning so the exhibition would be complete by opening night. It was with their inexhaustible energy and technical creativity that the ingenious designs were realized:
Rian Adams, Leen Apers, Thimothy Austin, Wiebke Bachman, Ioana Cristina Balasa, Teresa Ball,

Francesca Baratto, Joren Bass, Juliette Blangeot, Thibault Bloch, Kelley Bozarth, Fillipe Brando, Adelaide D. Brown, Chiara Carpenter, Sarah Margaret Carroll, Sofia Castricone, Alexandra Chaston, Roberta Chieppa, Valentino Colla, Stefan Cornelis, Erin Kay Davis, Sabine Debeury, Sandra Del Missier, Simone Del Pizzol, Nicola Dottori, Matilda Erikson, Jana Eske, Nicola Favero, Dino Favero, Stefano Ferro, Madsen Flurin, Rojia Forouhar Abadeh, Jan Fritsdal, Ines Fritz, Guilia Gabrielli, Zsigmond Gallo, Barbara Gasser, Bailey Gatens, Ole Gabriel Schanche Gilje, Pierre-Yves Gillet, Wolfram Glatz, Johannes Gomille, Rossana Gonella, Michele Gorman, Deidre Greaney, Hallstein Guthu, Eva Haggren, Robert Haranza, Tanya Hofmann, Katie Holmes, Katariina Hulkkonen, Andy Imki, Anna Iwanejko, Laurel Jackson, Wolfram Jantsch, Robin Jongenjan, Janne Kâhkànen, Leena Karppinen, Michael Kerr, Volker Kilia, Jessica Kleffner, Katy Kleinspehn, Peter Kocsis, Maija Korkeela, Riikka Korpela, Patrycja Kowalczyk, Awena Krell, Chris Kupski, Ryan Kwong Hung Li, Janne Laine, Anne Le Bleis, Christina Makrygianni, Federico Marcato, Francesca Marcon, Brian Matthews, Melinda Matuz, Clare Mc Evoy, Sarah Miller, Cristobal Montesinos, Filippo Mursia, Alexandra Nafpliotis, Callie Narron, Achim Naumann, Steffan Oestreich, James O' Hare, Lisa Oregioni, Caitlin Osborn, Anthony Panagiotopoulos, Marc Perrotta, Yvette Pistor, Dimitris Pompadopoulos, Maryam Pousti, Laura Pujola, Johanna Ramu, Steve Reynolds, Baptiste Robin, Lola Rieger, Sam Rosenthal, Bence Sarkany, Gregor Schmidtauer, Lana Schuttleworth, Robert Speight, Cindy Stelmach, Elena Stoppa, Romana Suitner, Annamiia Suominen, Marc Thurow, Vikrant Tike, Devis Titton, Hiroyuki Toyoshima, Nikola Uzunovski, Annika Vaisanen, Simon Vanoutyrve, Eini Vasu, Irene Ventrucci, Alessandro Vergot, Beto Villar Watty, Marco Visentin, Amanda L. Whittemore, Marja Yliniva, Catherine Young.

In closing, I would like to thank Lucas Dietrich for agreeing to publish the book and Judith Gura who had the brilliant idea of introducing the two of us for this purpose. All the people at Thames & Hudson have been dedicated to the production of this catalogue. The success is due in large part to the work of two extremely hard-working and talented people, Catherine Hall and Peter Dawson; with Catherine's tenacity and Peter's exquisite book design, I am happy and proud to present *The Snow Show* to all.

Lance Fung

I would like to dedicate this book to my loving and supportive family: William, Marian, Jonathan, Allison, Ayla and Buster. Although my father, William, did not live to see the final exhibition, he along with each member of my family encouraged me to follow my passion and vision with 'The Snow Show'.

Jacket and book design: Grade Design Consultants

Foreword text © 2005 Mary Jane Jacob
Introduction text © 2005 Lance Fung
Project descriptions © 2005 the artists and architects
Methods and Process text © 2005 Jeffrey Debany and
Noémie Lafaurie

First published in 2005 in hardcover in the United States of America by Thames & Hudson Inc., 500 Fifth Avenue, New York, New York 10110

thamesandhudsonusa.com

Library of Congress Catalog Card Number 2004111176

ISBN-13: 978-0-500-23819-6
ISBN-10: 0-500-23819-7

Printed and bound in China

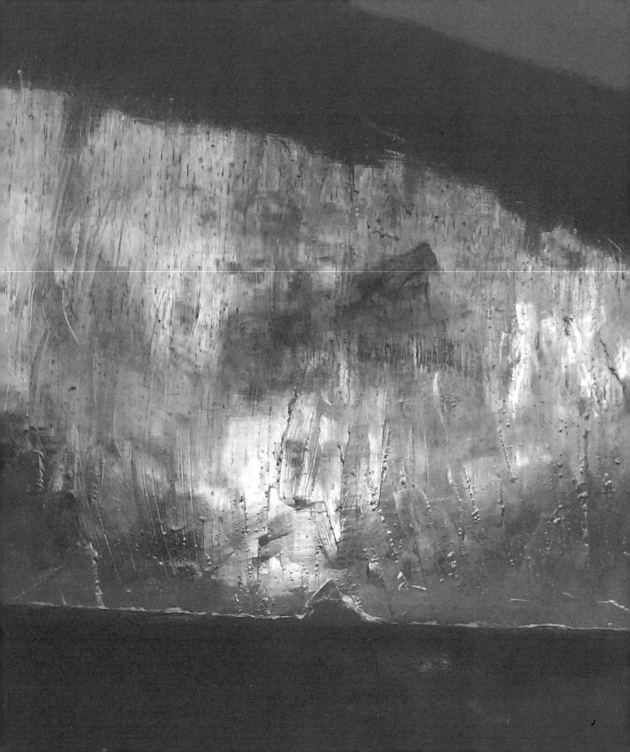